WHISPERING

PINES

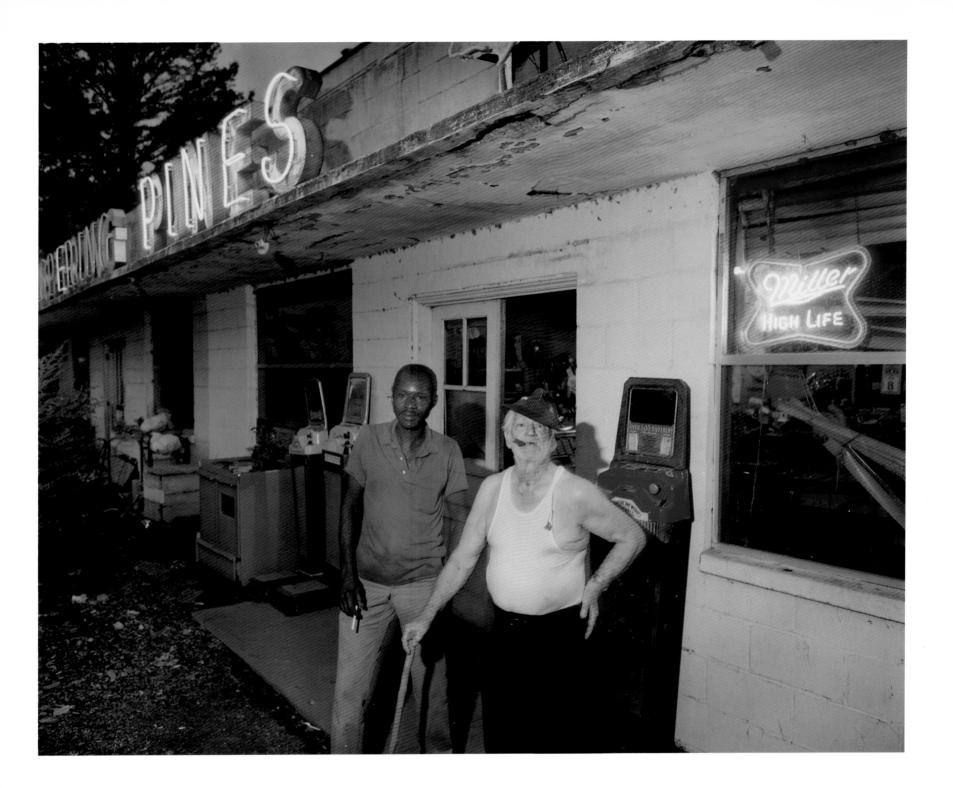

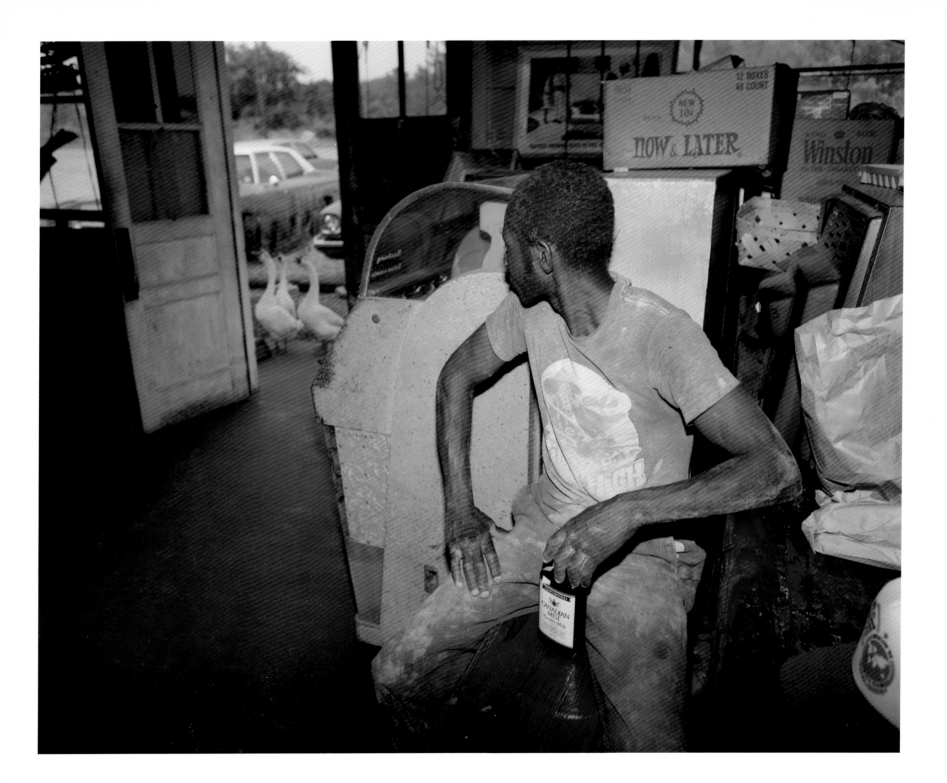

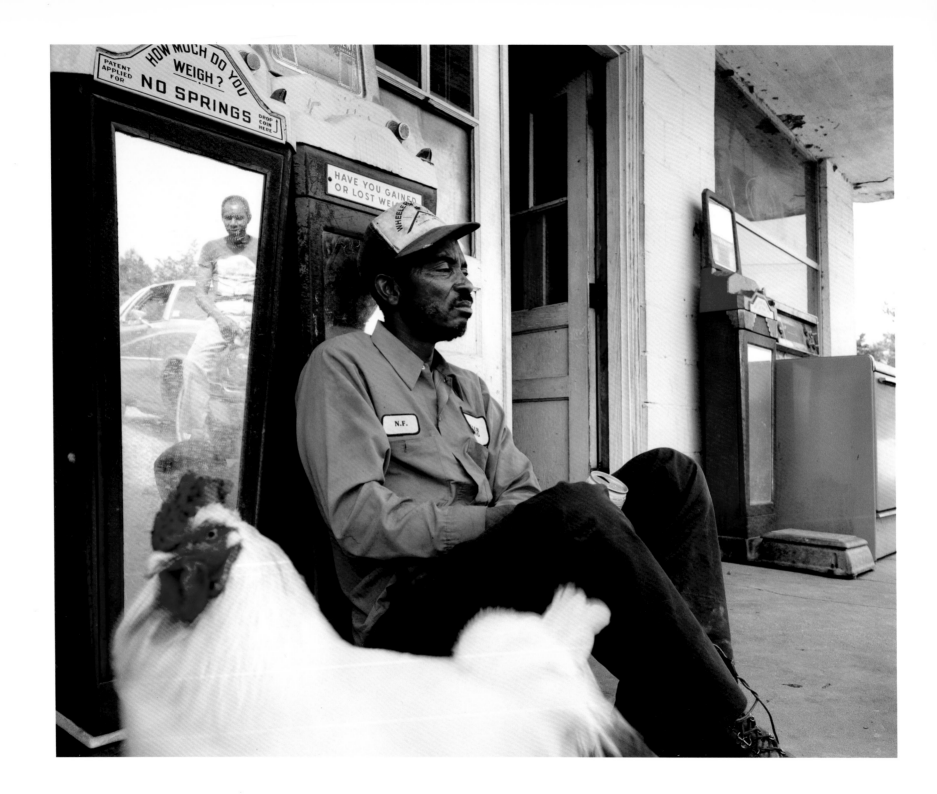

WHISPERING PINES

Birney Imes

■

INTRODUCTION

BY TRUDY WILNER STACK

UNIVERSITY PRESS

OF MISSISSIPPI *Jackson*

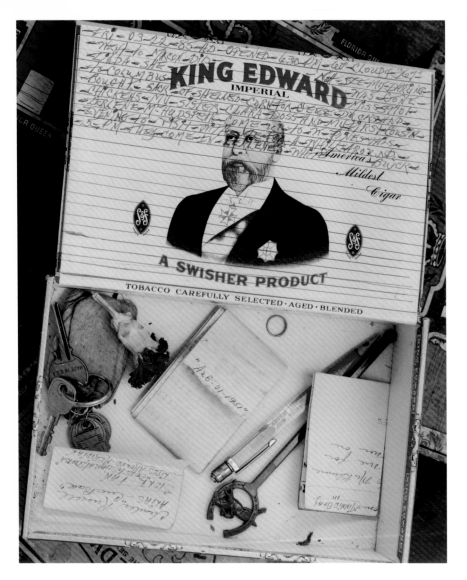

Copyright © 1994 by the
University Press of Mississippi
Photographs copyright
© 1994 by Birney Imes
Introduction copyright © 1994
by Trudy Wilner Stack
All rights reserved
Manufactured in Singapore
First Edition
CIP Data appear on page 96.

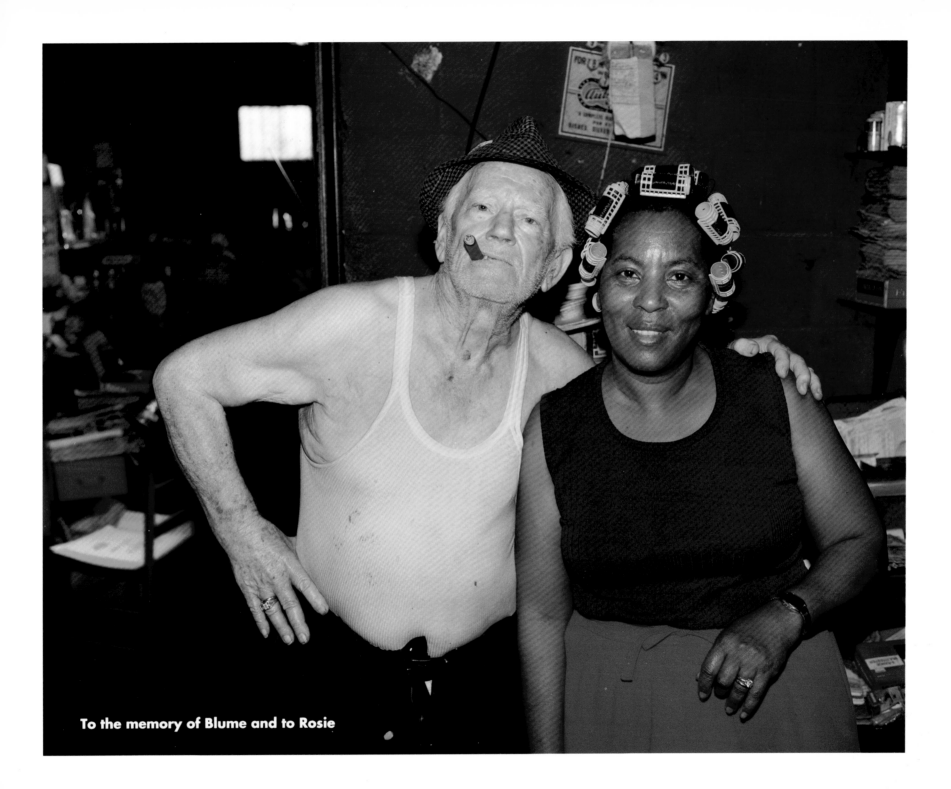

To the memory of Blume and to Rosie

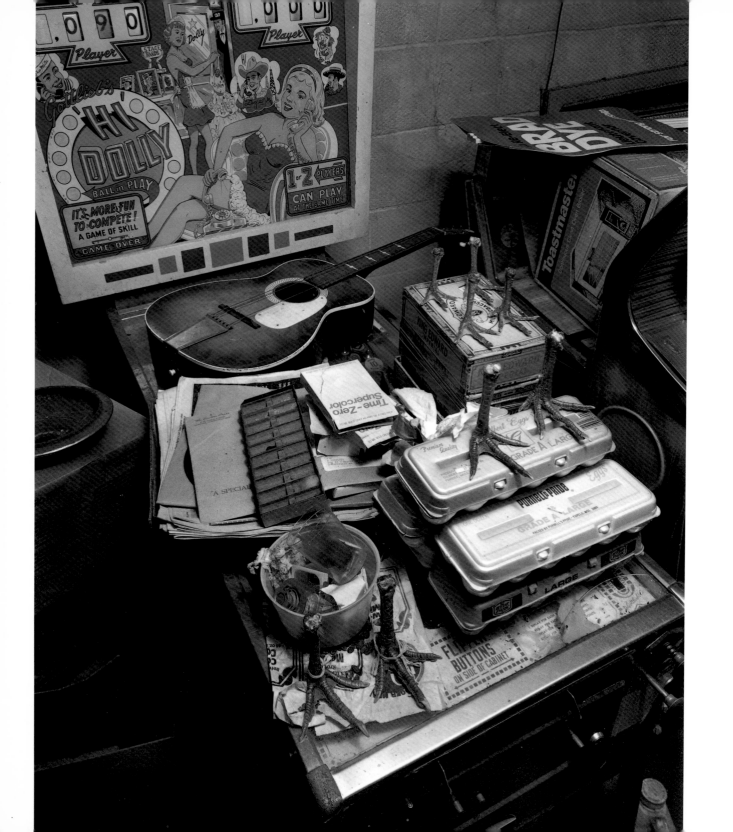

INTRODUCTION

What *is* down the road a piece? When you are roving the rural byways of the deep South, questions of where you might be, where you are headed next, and what you might find there, have a palpable indefiniteness. Ominous and seductive to outsiders, for insiders the region evokes a lost and found feeling that accompanies an intense sense of place. Birney Imes, a native resident of Columbus, Mississippi, both knows his home county and is a stranger to it. Photography has been his means of introduction to the Mississippi he wasn't sure of. The camera allows him to cross the unseen lines of familial, racial, and class territory that too often restrict understanding among locals. When he returns to his house in town at the close of a long country day, over before he was ready, he brings with him an enlarged sense of where he might be from. And sometime later, he returns to his subjects—with pictures, with stories, with visitors. He comes back, touches base; he doesn't replace the people with the photographs—he takes care that their Mississippi grows with his.

The mirage of an oasis comes to mind when I imagine the searching photographer's first glimpse of a declining roadhouse off in the distance: "Whispering Pines" (a dreamy sort of name) growing quickly larger and more real in his dusty windshield. This place, a fountainhead of visual confusion and excitement, became a perennial personal and photographic source for Birney. He found himself part of the scene as saloon photographer, "my friend Birney Imes," just another Pines character, faceless in his telling photographs, but behind them all. Steady, eminently sane, with a devilish appreciation of the eccentricity and ribald humor of others, he was a welcome addition in his role as official documentarian and straight man. Since the mid-seventies, he, like other favorites, floated in and out of the string of days (40 years worth) which hung before the aging proprietor and his long-time right hand, Rosie Stevenson. Birney's modest nature and stability reassured Blume Triplett, master of the Pines, a man who got left behind in a swirl of social change and decrepitude: diminished but still spirited, he lived in sensational physical disorder that was the manifestation of a vast assemblage of memories, all keepsakes.

When Blume died in 1991, his photographer

friend was left with his own recollections and "all that stuff," the archives of an old man's life and the other histories of which it spoke. Birney had made sense of things with his camera before, and so again he made photographs. Now a virtual archaeologist, digging through filth-laden remnants, he uncovered the bits and pieces that Blume would never dispose of, the significant and the insignificant, a collector's fortune. The organization of the images in this book allows the most recent photographs, the cigar box arrangements of these relics, to be viewed together with the intimate scenes of the waning Pines in action. Both series are layered glimpses, the compressed sediment of a rich river of activity run virtually dry. The cigar boxes heighten and enclose the vestigial sense; they are packed with fractured lyrics from the past, like bits of the catchy, scratchy juke box tunes that long floated through the air of the Pines. The postmortem still lifes that complete this volume provide a moving coda to the book's reverie.

Blume Triplett, and by extension, Whispering Pines and its players, symbolized coexistence in Mississippi. It was a strange microcosm that allowed Birney Imes to enter not only the present but its past as well. He left the road and with the acuity of a historian, the sensitivity of a folklorist, and the intimacy of a family member, searched and salvaged the remains (people and things) of a social nexus that seemed to have it all. Themes that play around the edge of all of Imes's photography came together: the racial harmony and hatred that survive in a precarious equilibrium had names and faces at the Pines. The building itself had long been divided between white and black, but, as Blume fell into old age and ill health he became dependent on Rosie for everything; the Pines's white side became so overrun with his beloved ephemera, much of it a tribute to his lost wife, Eppie, that integration was gently and organically forced—in time, all comers congregated on the black side. They were united by Blume's mementos of a past that would not have permitted such gatherings, and the strength of his trust in a black woman whose loyalty deserved whatever he had to give, eventually even an open mind.

Photographs were everywhere in the Pines: some were Birney's and some were Blume's snapshots and Polaroids. There were old family portraits and a clutter of printed images. All these likenesses converge in the Whispering Pines pictures Imes has made. He uses the rephotographed imagery as portals into time, foils to his own photographic enterprise which explores the detachment of the Pines from contemporary life. Imes found a place on its own slow clock, held up by history as recorded by Blume, an unconventional chronicler, and told in a remarkable material account. Through Imes's lens, Blume's presence, whether explicit or not, becomes incessant, relied upon: we expect to see him in every shot. But as the body of the old man sags—only the habit of the cigar dangling between his lips keeping it there—he slips away, blasting his way into the heavens, shooting at the stars.

Trudy Wilner Stack

Curator of Exhibitions and Collections
Center for Creative Photography
The University of Arizona

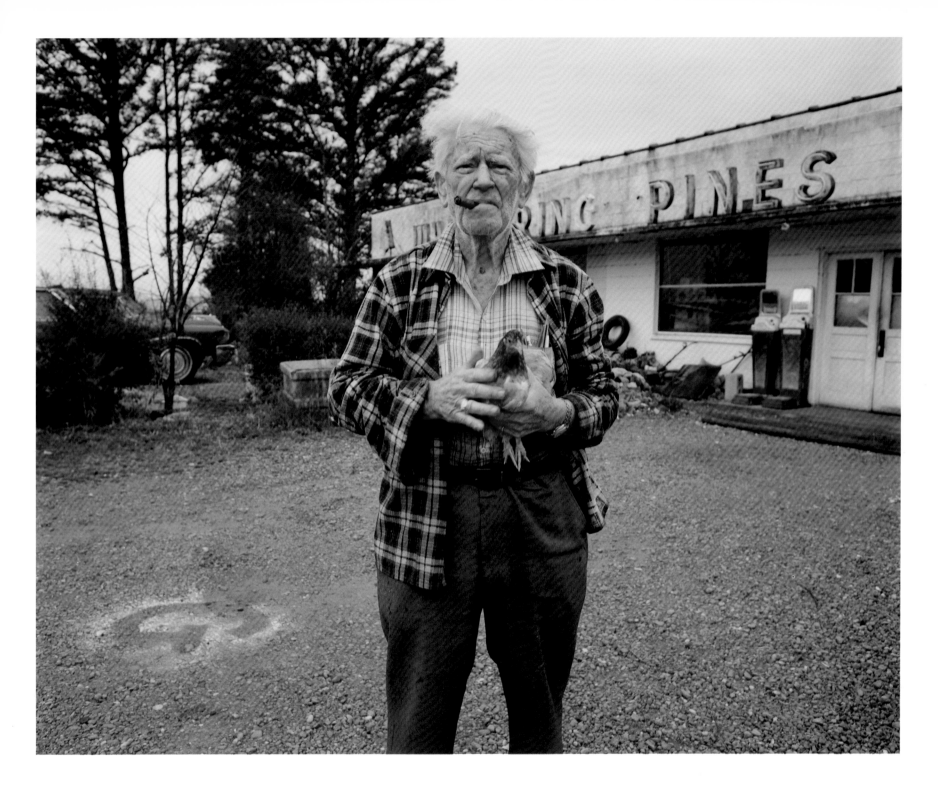

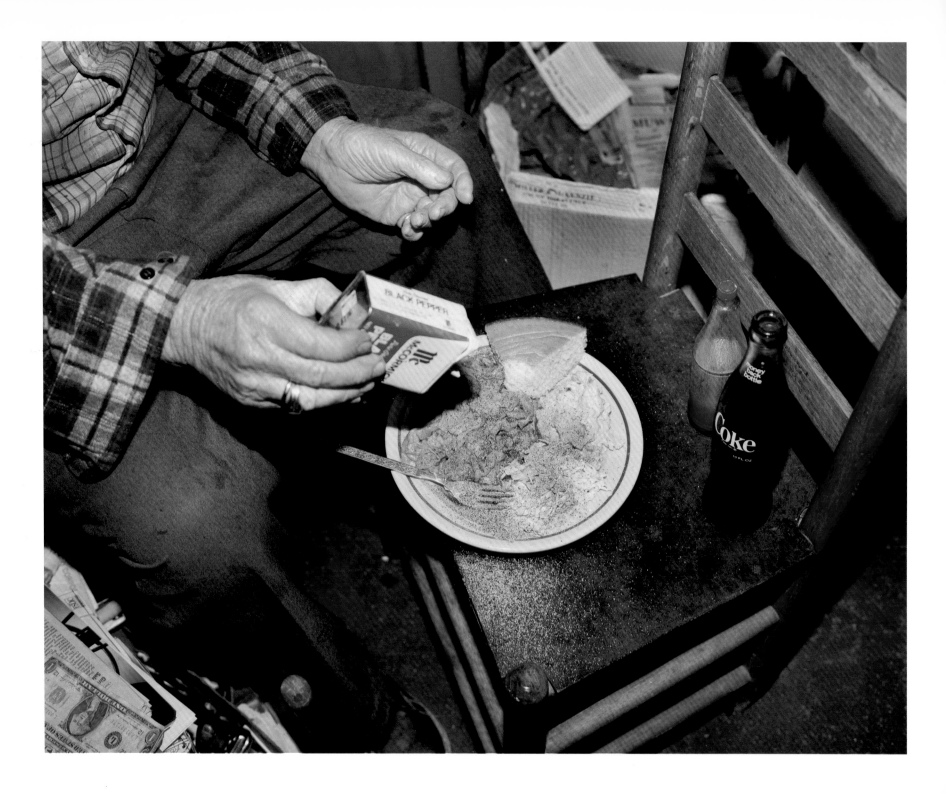

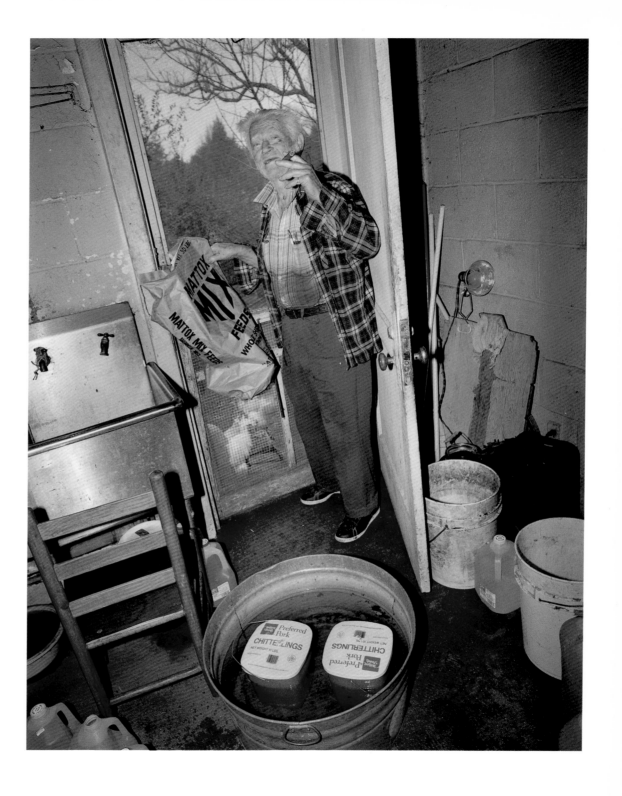

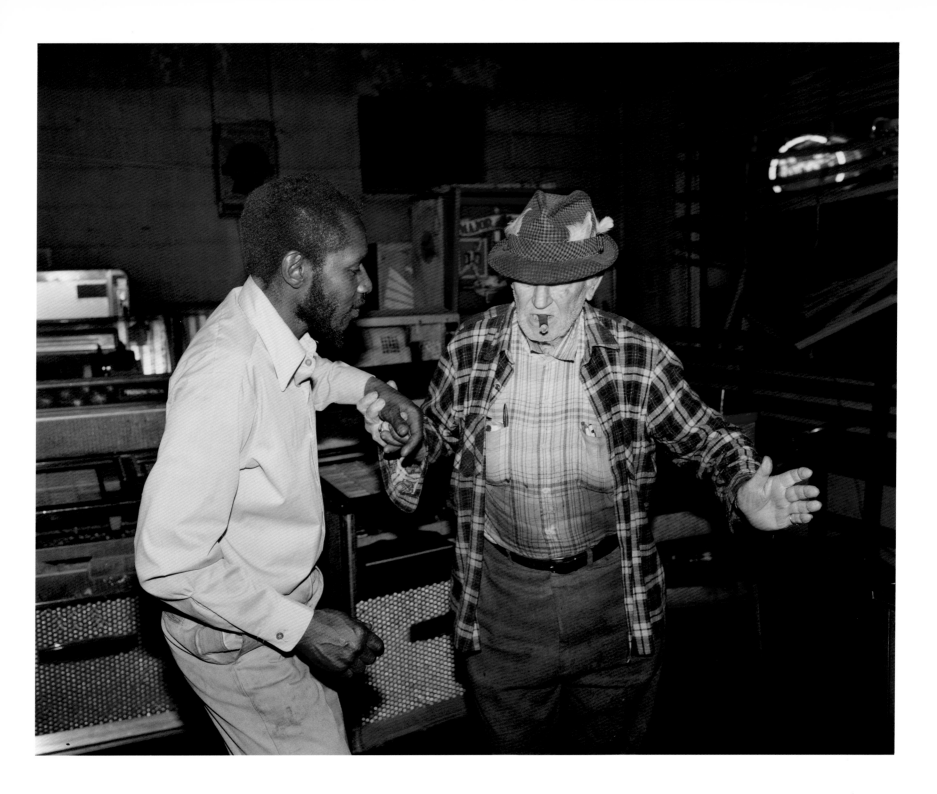

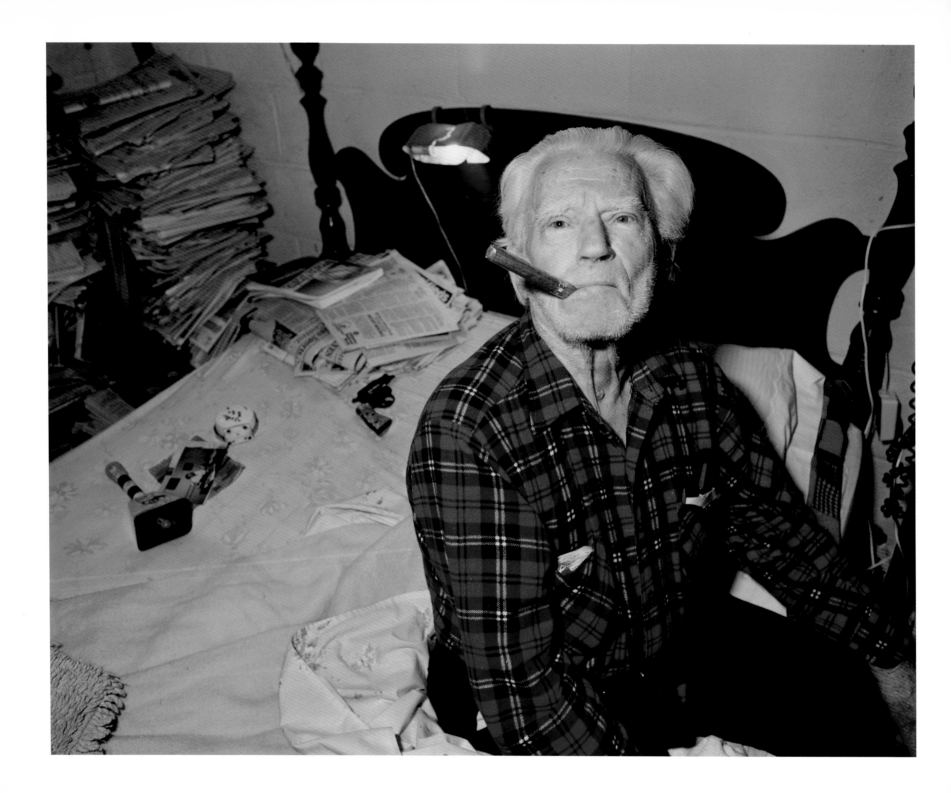

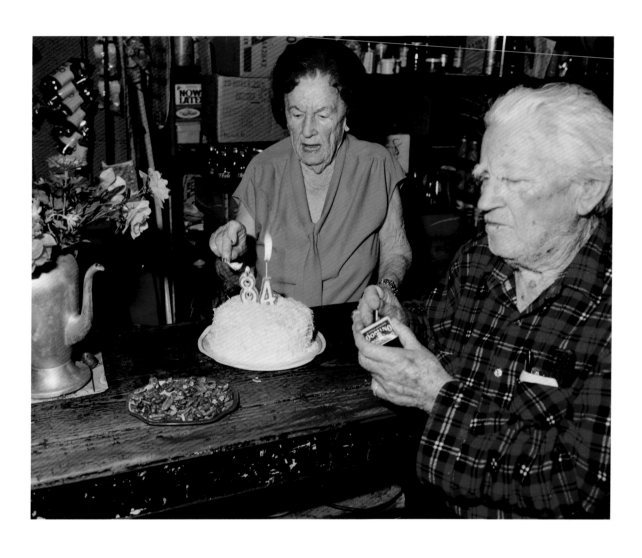

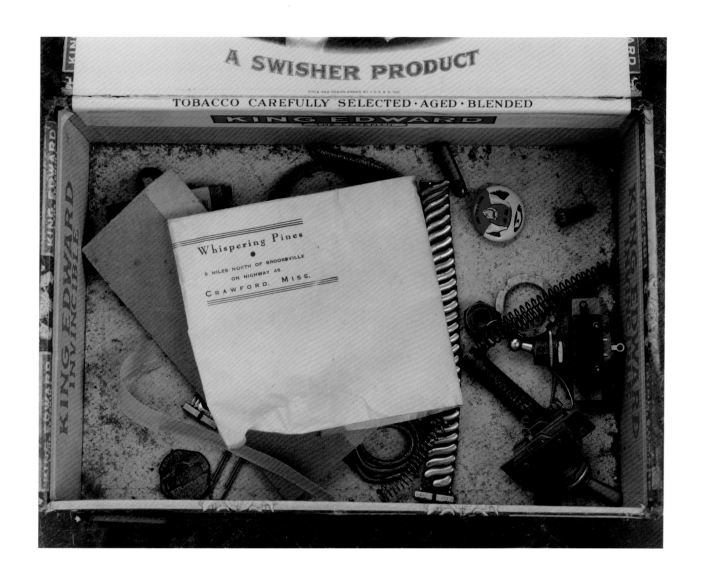

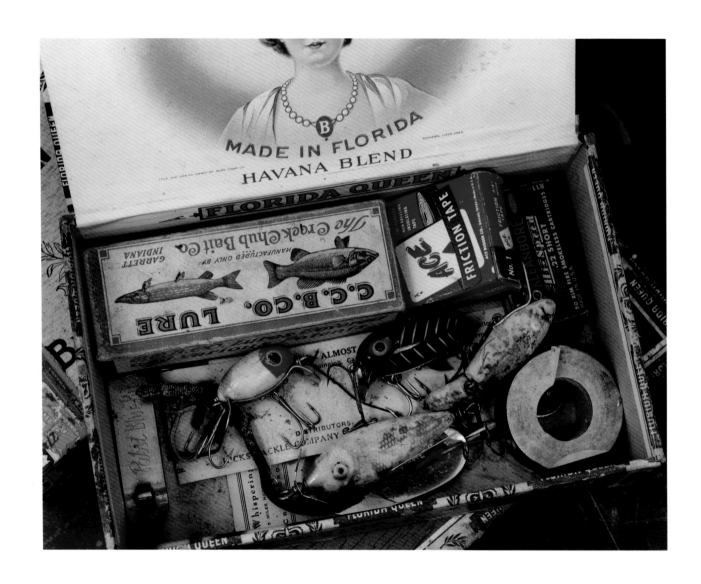

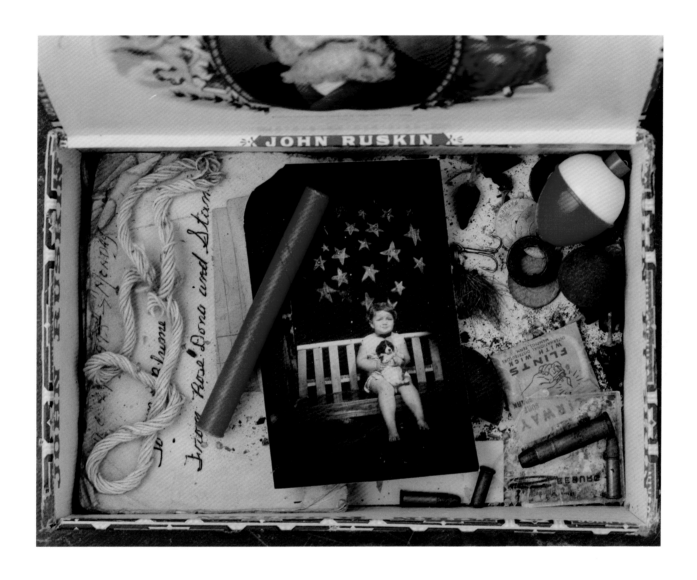

25

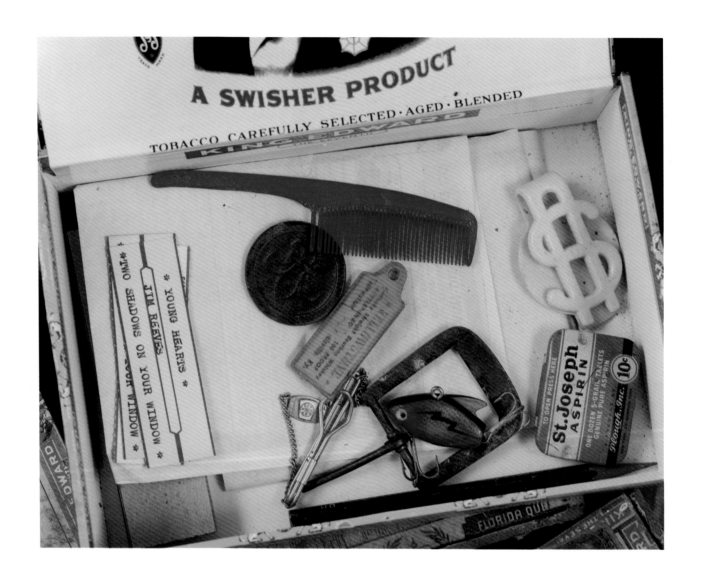

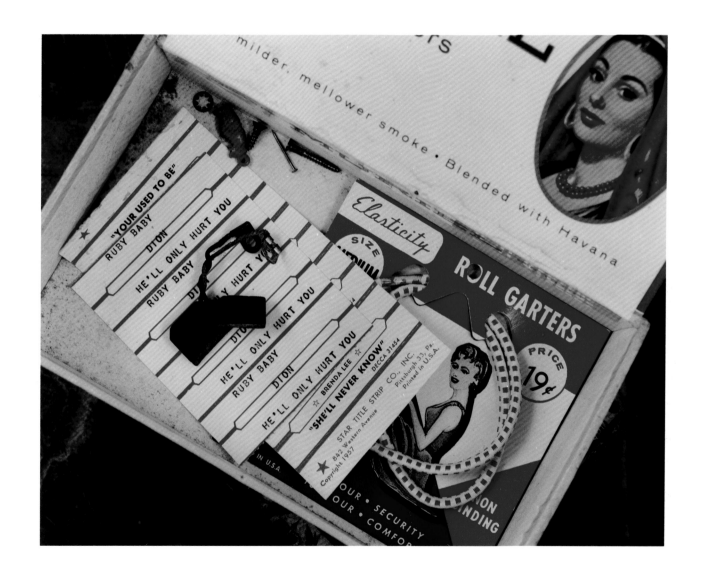

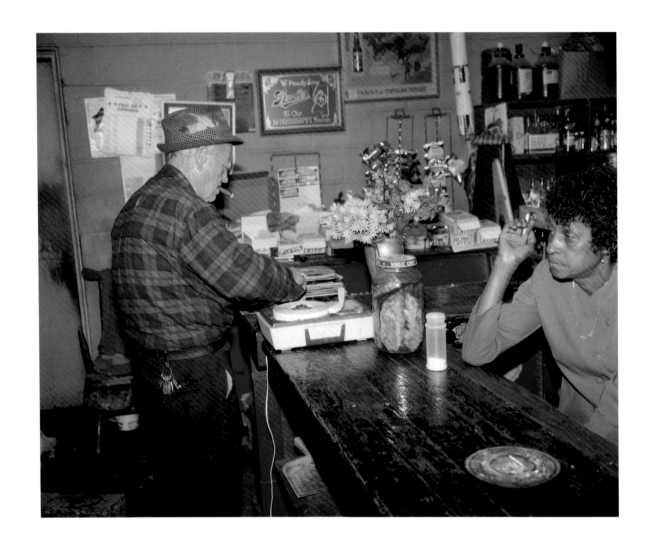

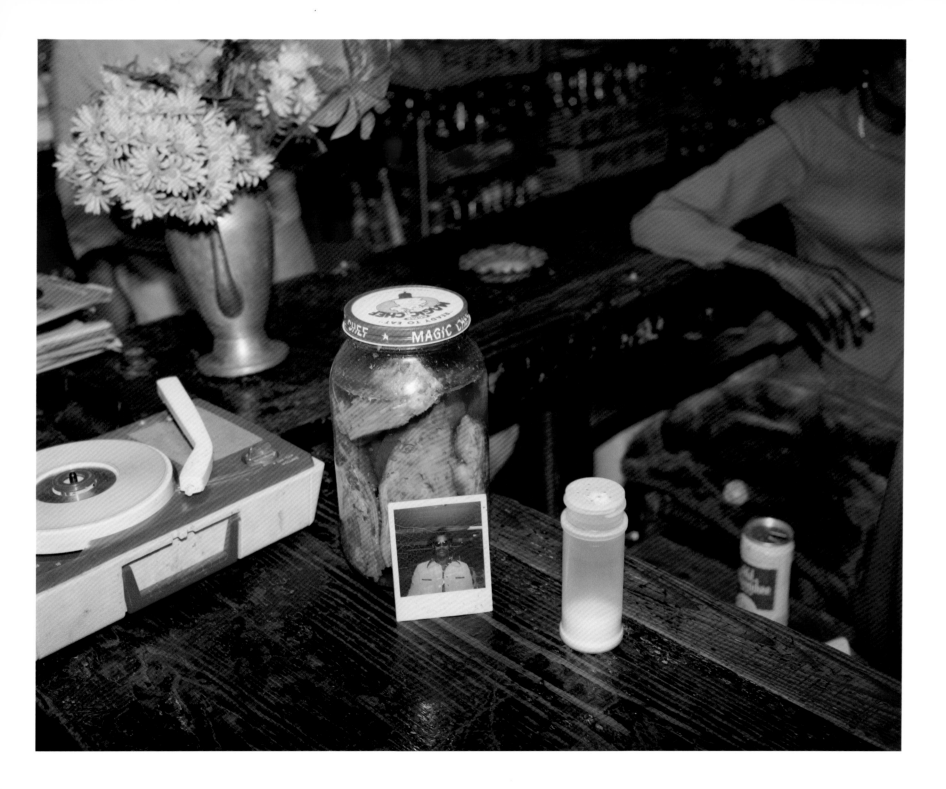

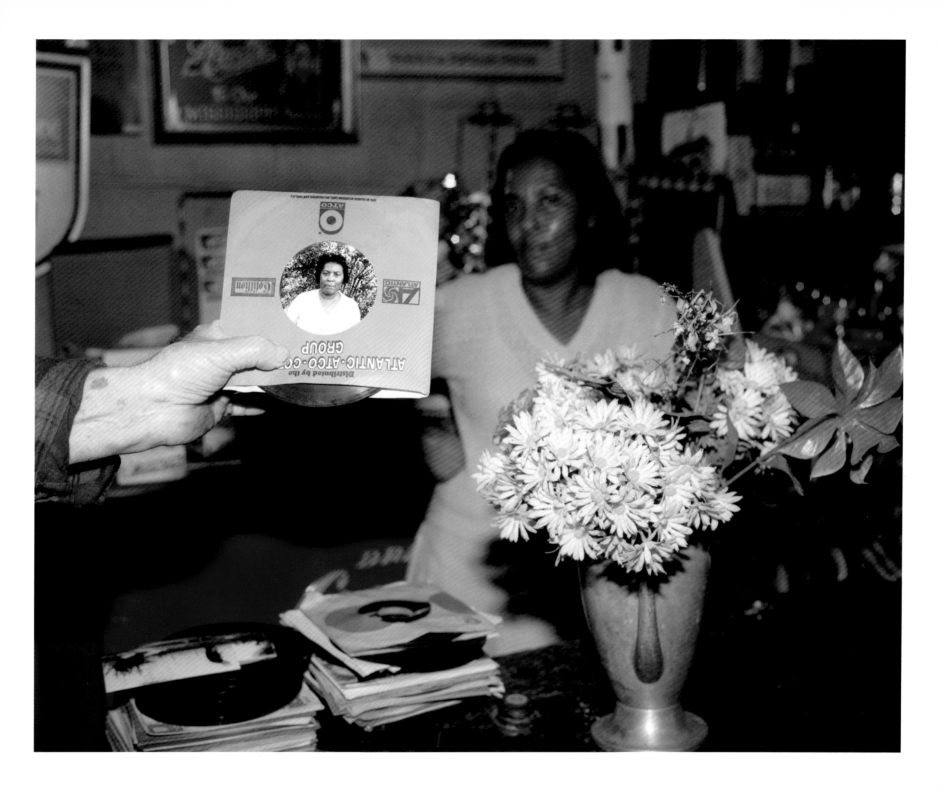

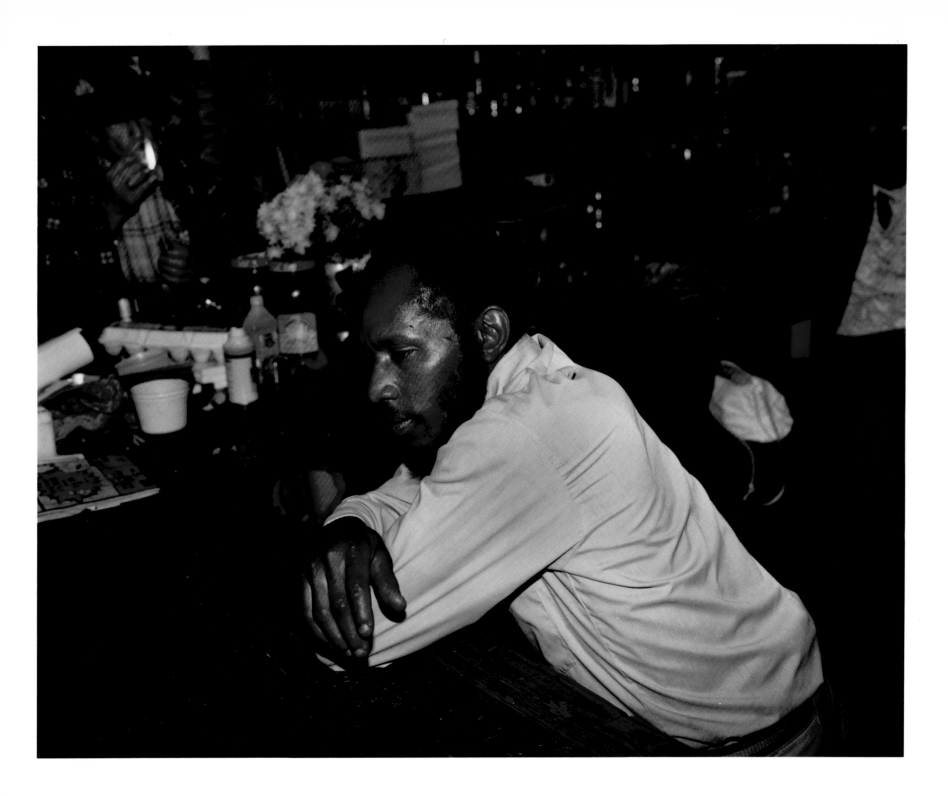

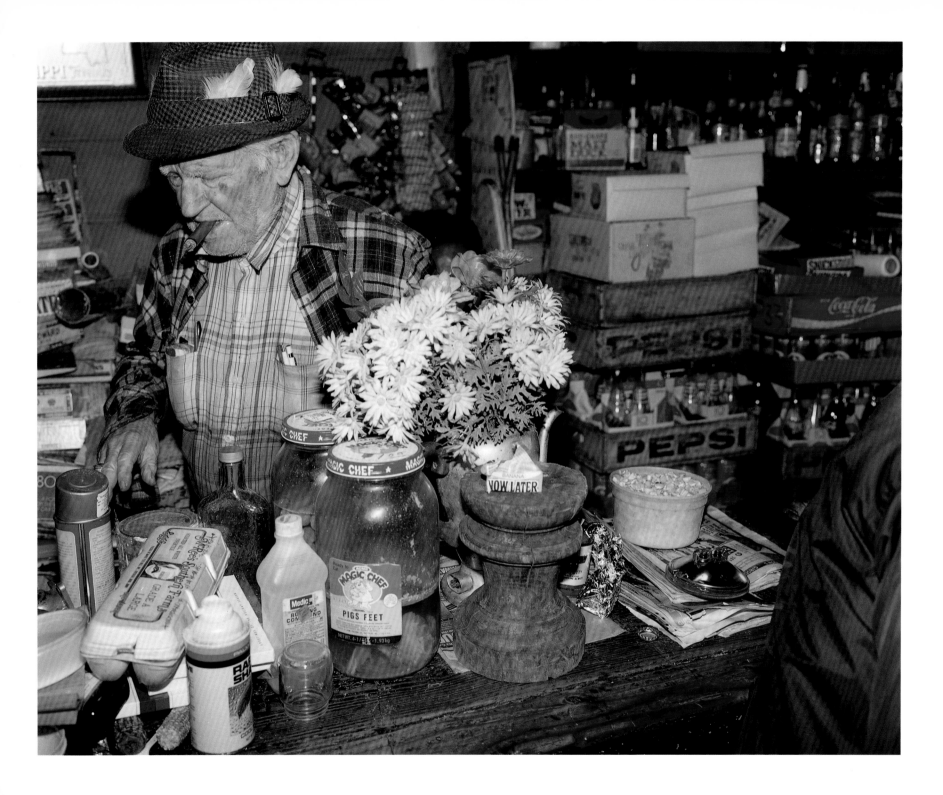

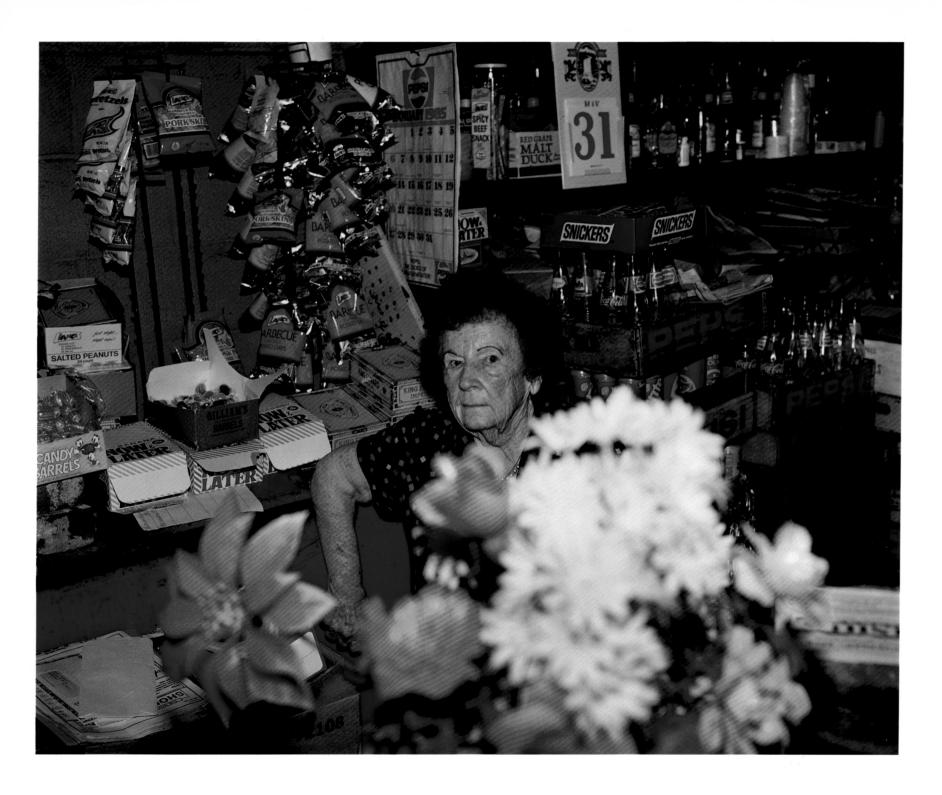

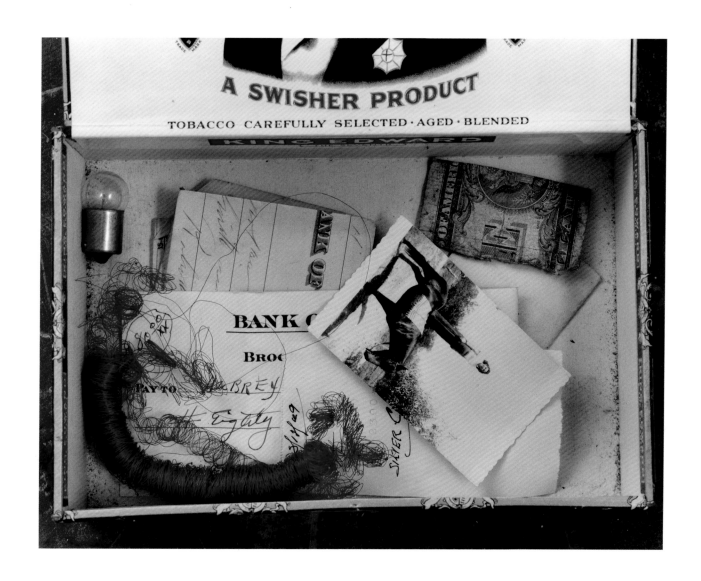

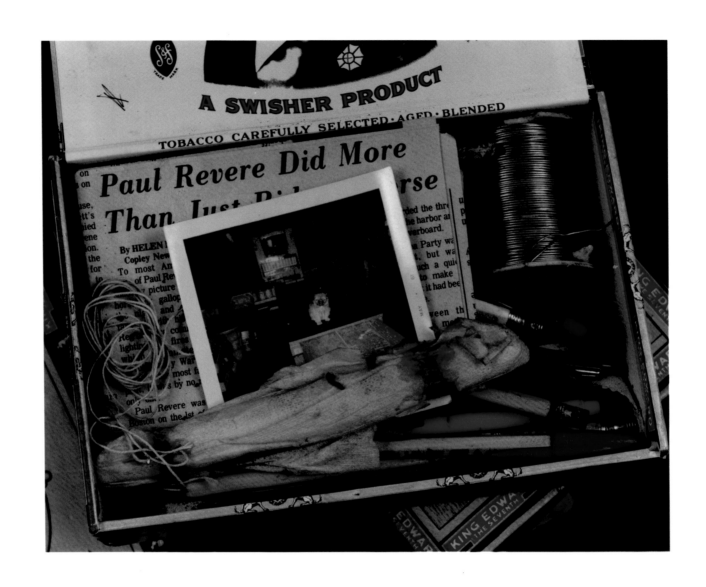

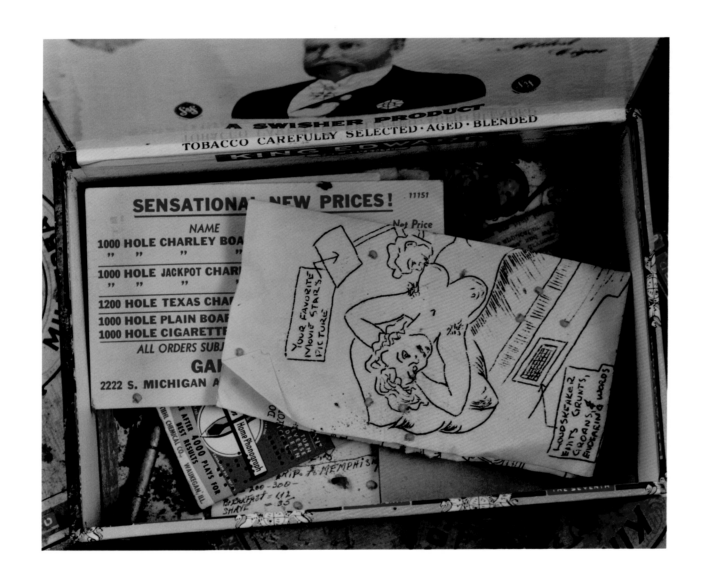

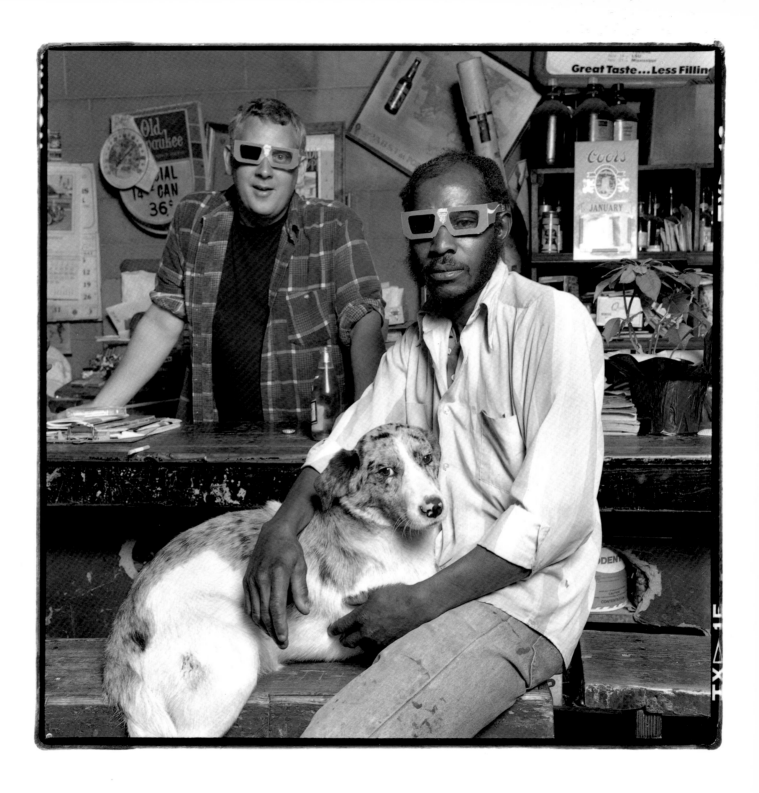

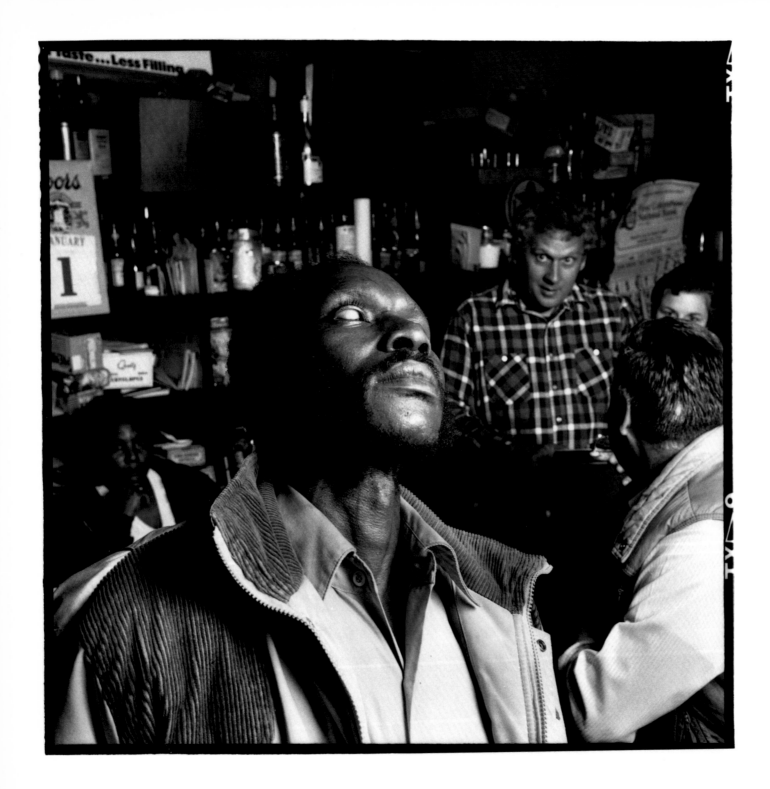

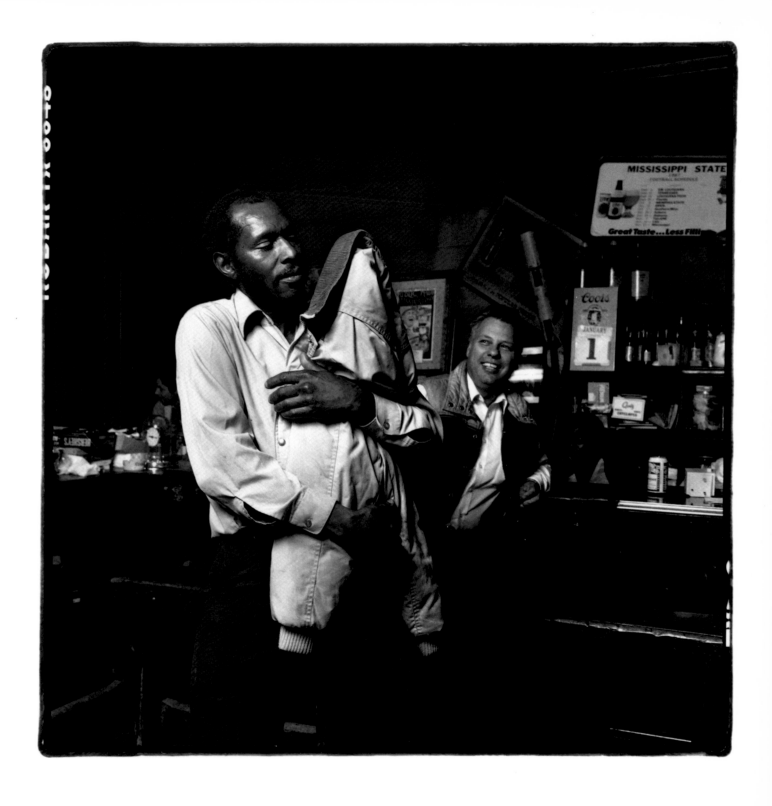

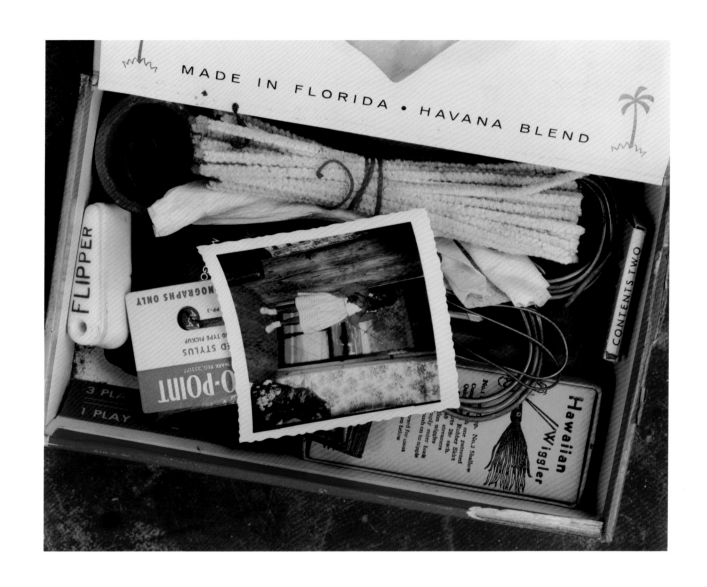

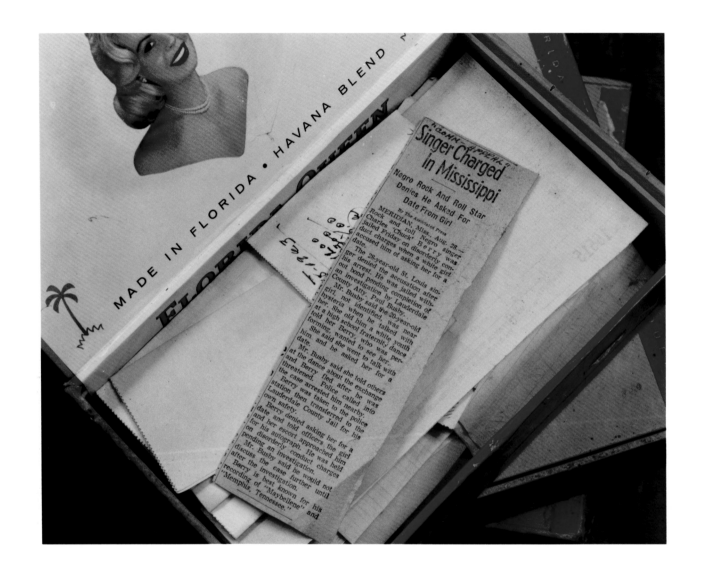

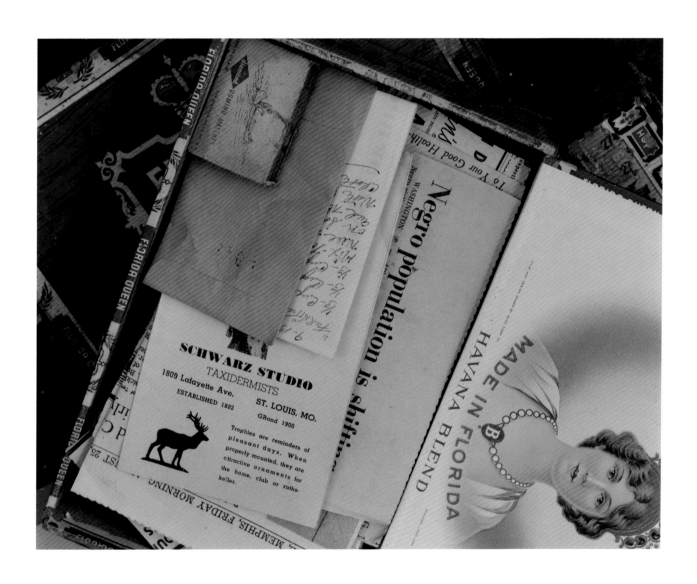

49

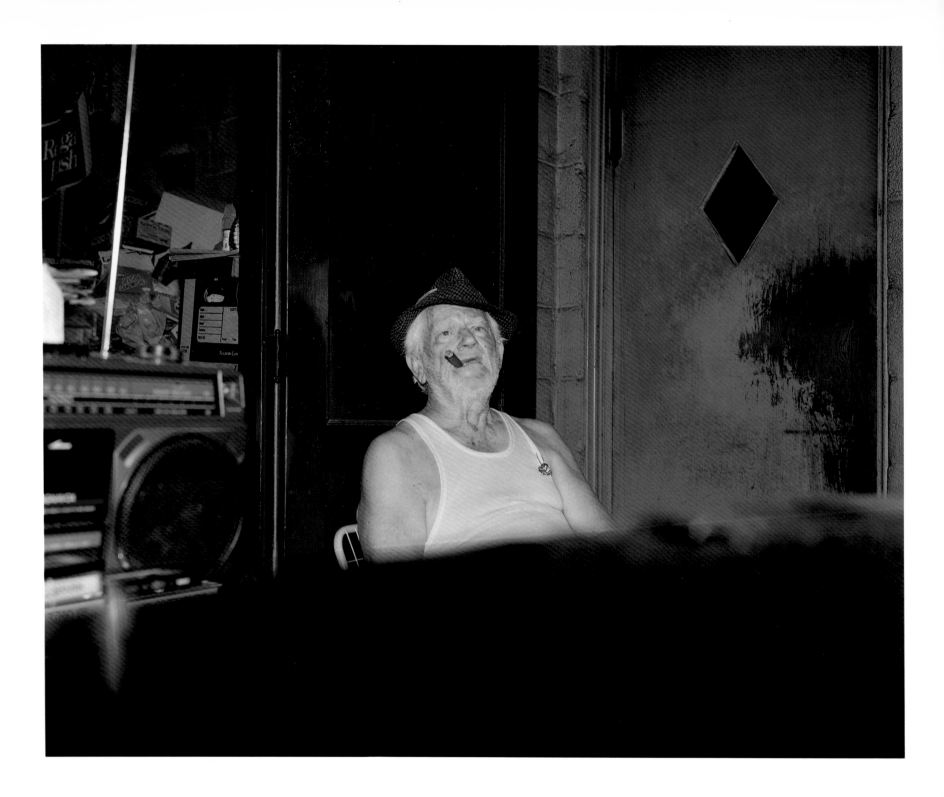

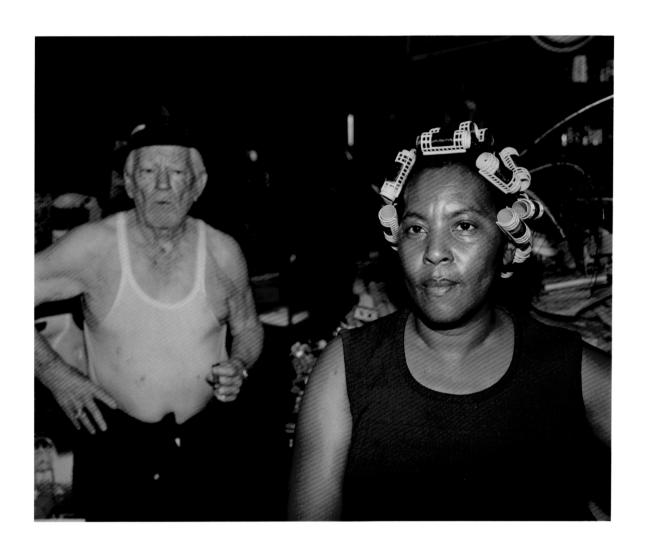

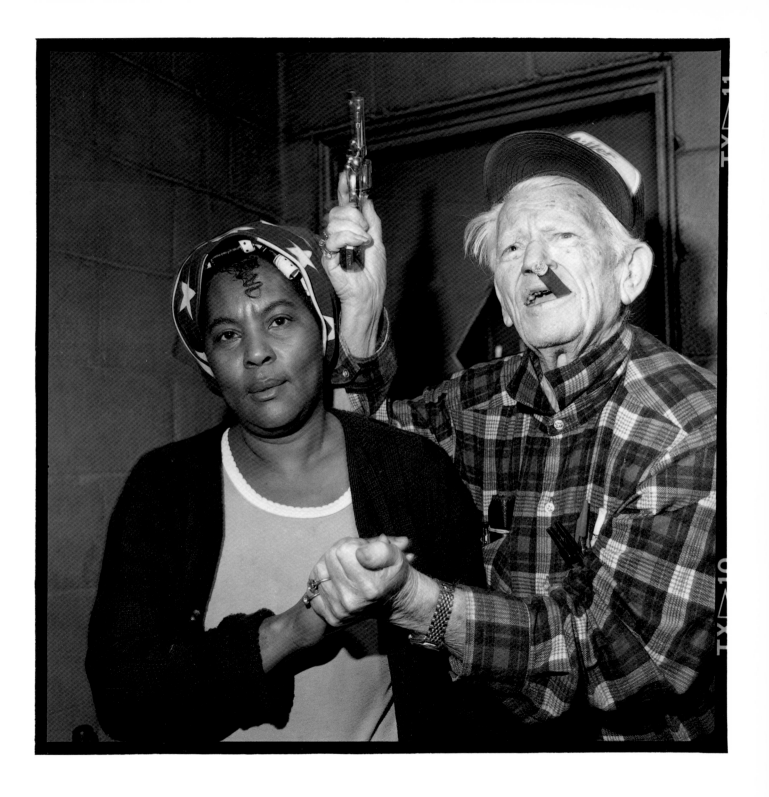

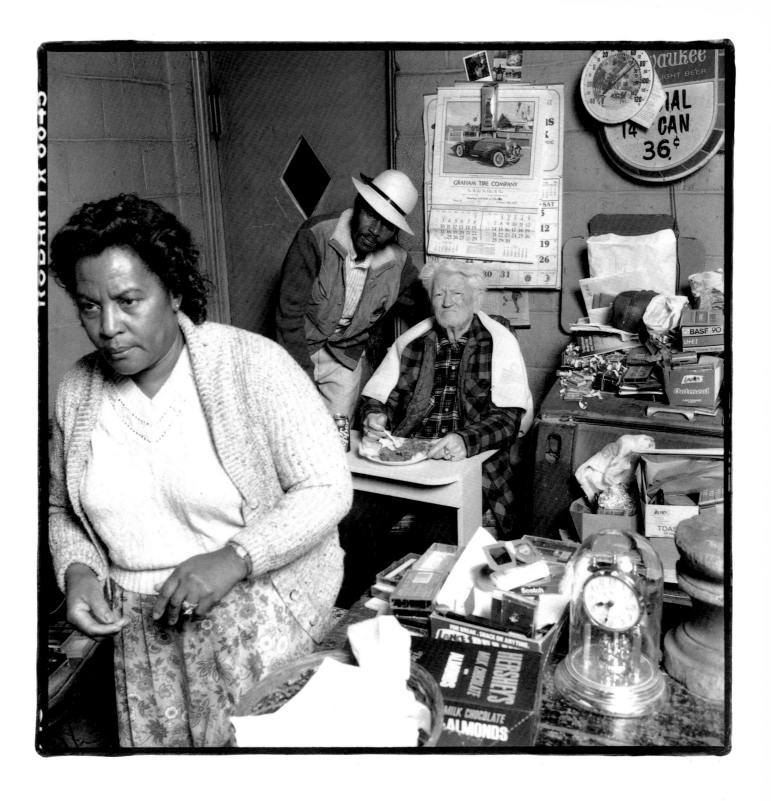

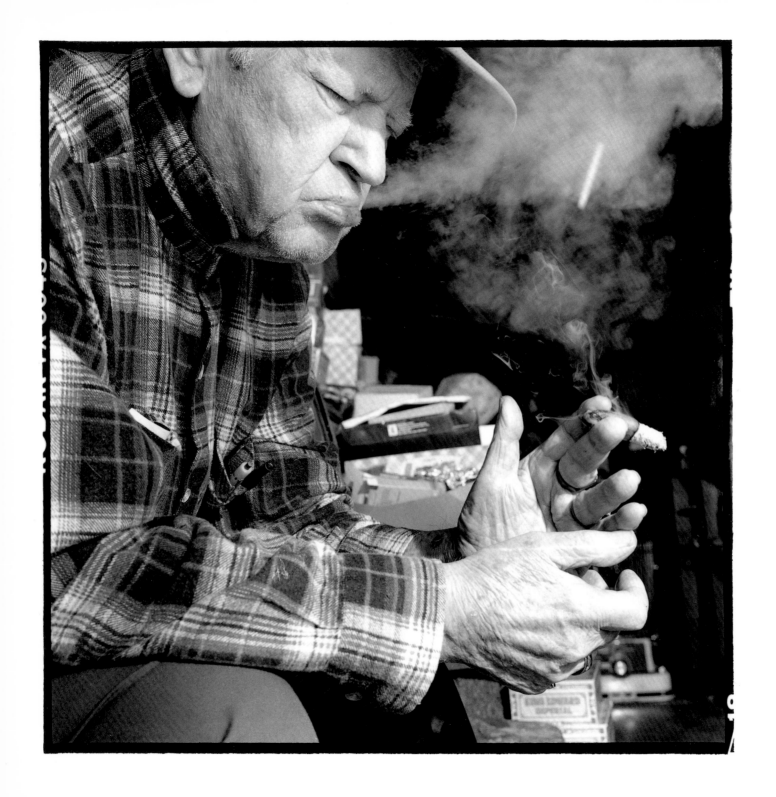

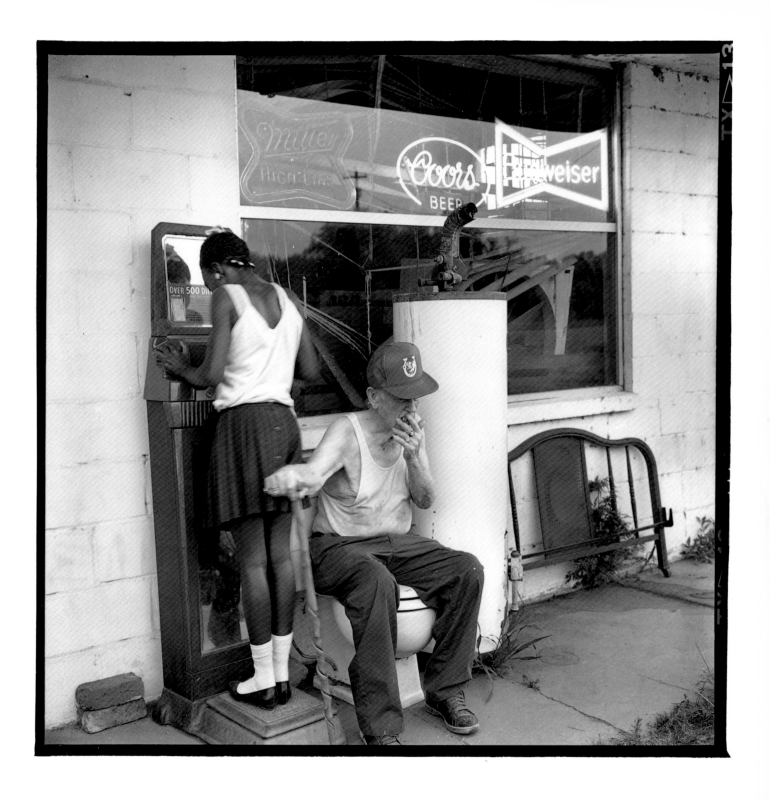

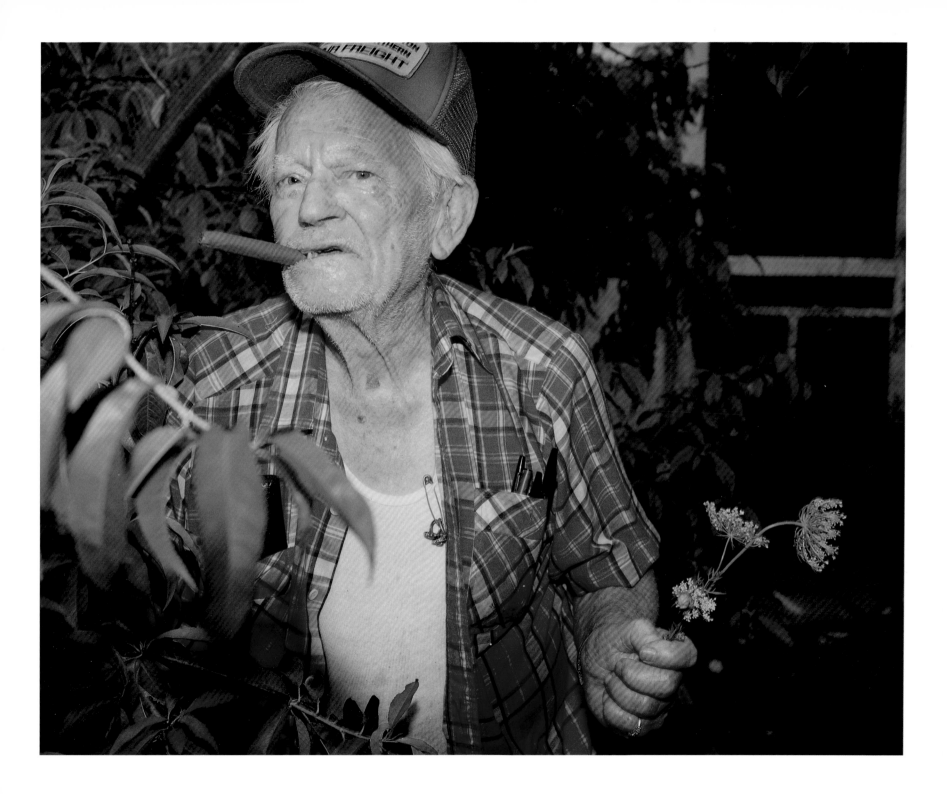

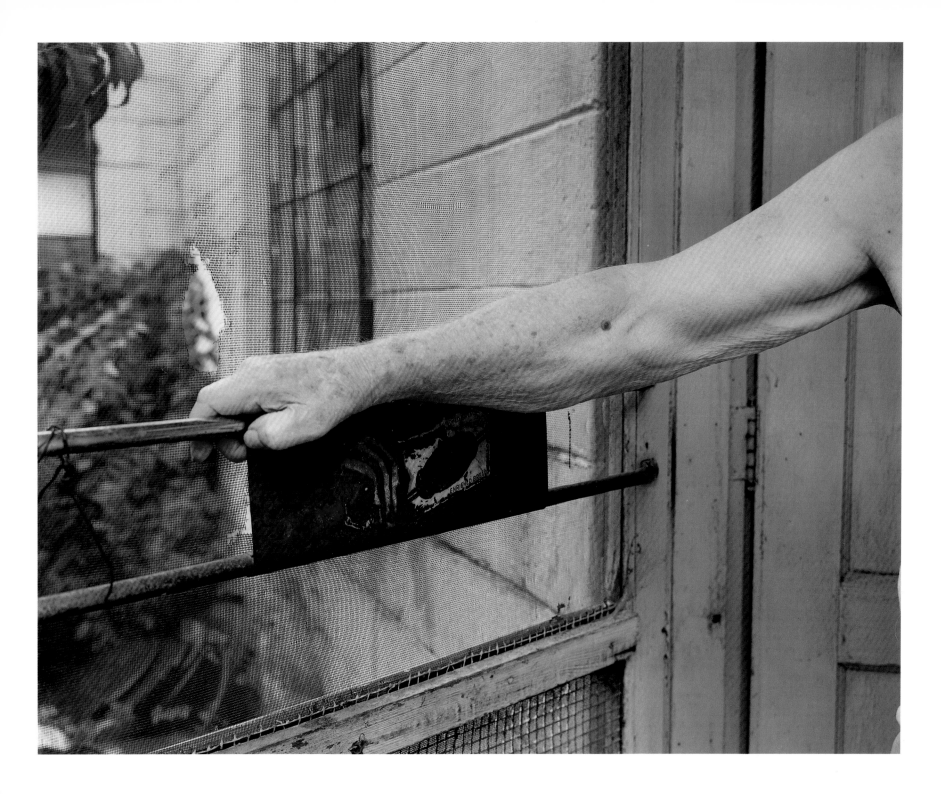

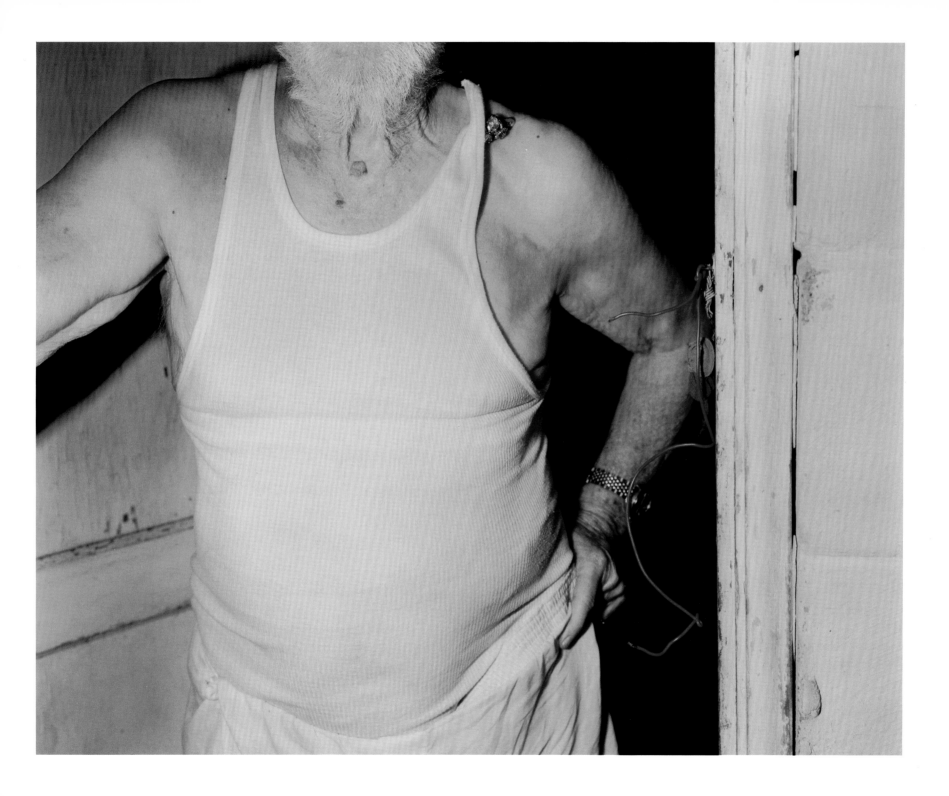

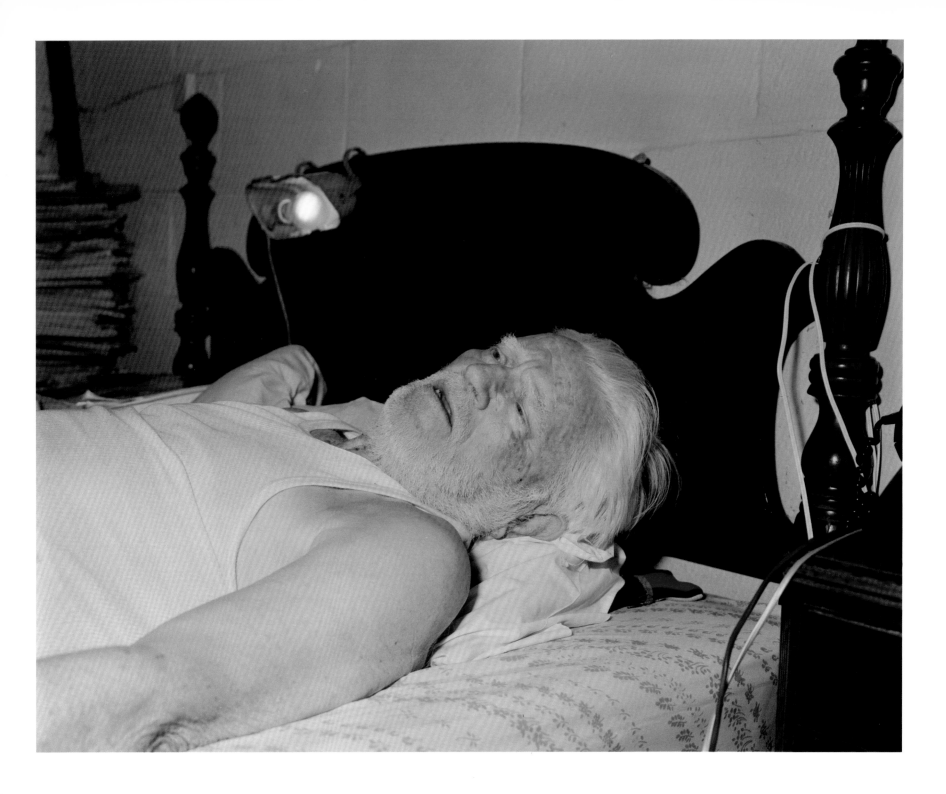

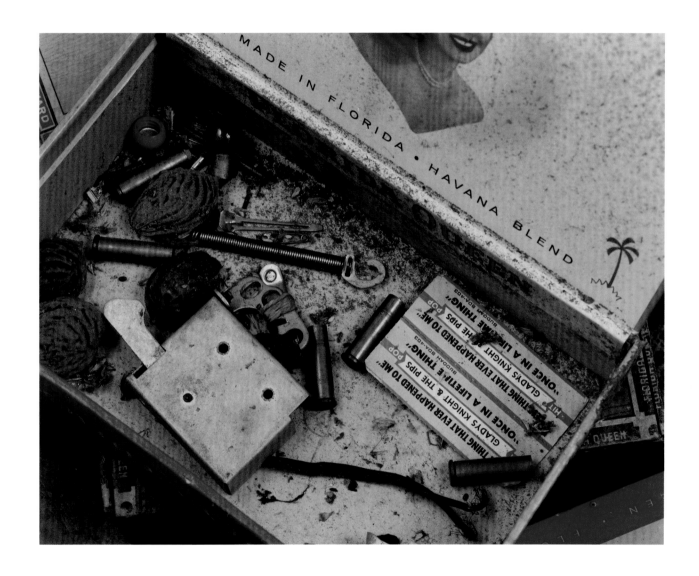

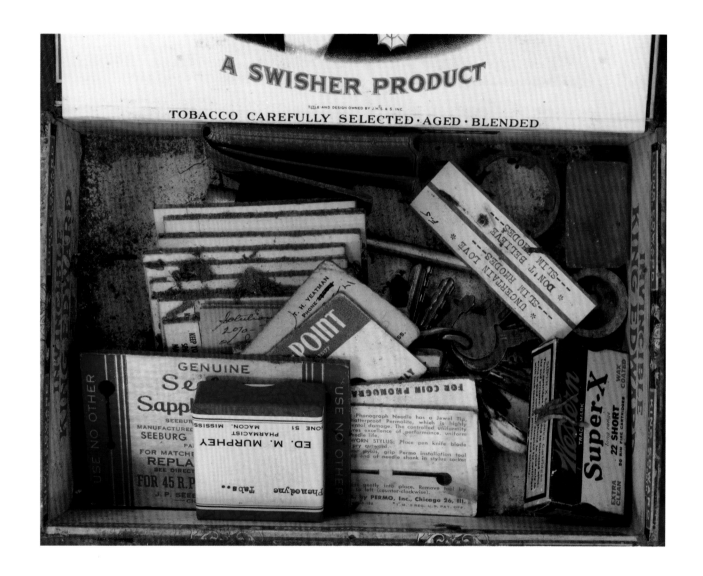

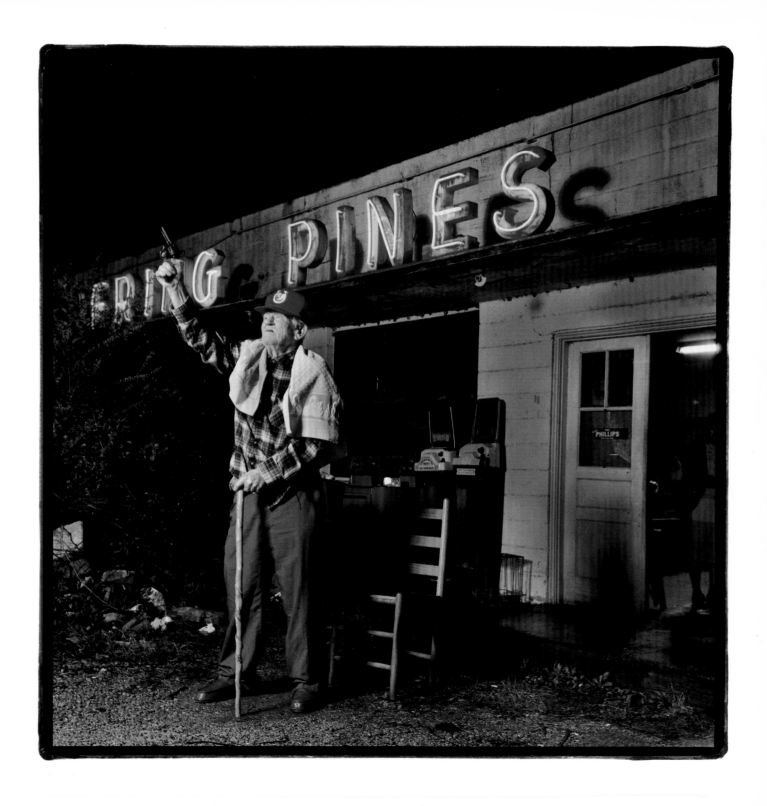

THE PINES

A REMEMBRANCE

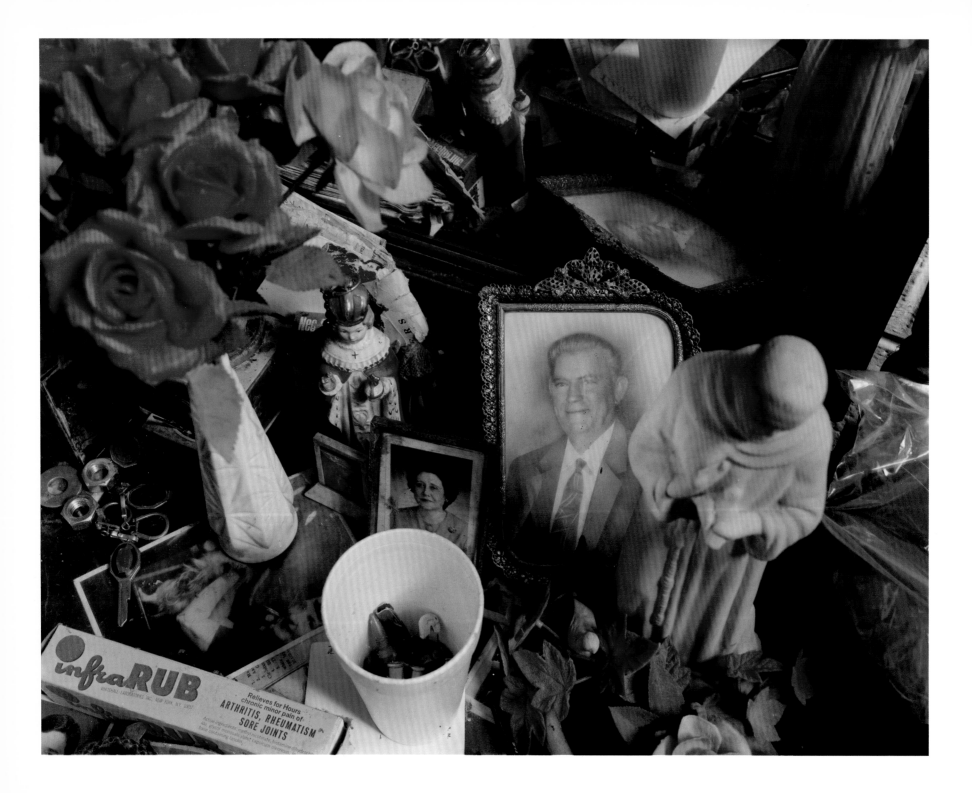

It must have been 1975 or 1976 when I first set foot in the Pines. I had just begun photographing seriously and would spend hours driving back roads looking for a site or situation to photograph. It didn't take long to stumble upon the place— the "Eppie's Eats" sign out front, the rusting cars, the hedge in the parking lot dividing the White Side and the Black Side, and the stuff—it was everywhere inside and out: coin scales, pinball machines, jukeboxes, lawn mowers, old campaign posters, newspapers, guns, cigar boxes, and beer signs. It was overwhelming, and it was irresistible.

At the center of it all was Blume Clayton Triplett, born in the Winston County, Mississippi, community of Locafoma in 1902. Blume had moved to Brooksville in nearby Noxubee County in the early twenties to open a mechanic shop and sell Model T Fords with his brother Howard. On Christmas Eve in 1921 Blume married Eppie Cunningham, and it was for Miss Eppie that he built the Pines almost thirty years later. In the intervening years Eppie bought and managed a sawmill during the Second World War (the only woman in the country to do so, according to the newspaper clippings) and later a cafe in Brooksville. When Eppie wanted a larger and nicer place, Blume built her one just over the county line where the selling of beer was legal.

Right where you're sitting, son, we opened it up on Saturday, October 8, '49. Just thirty-six years ago. We didn't have the White Side opened up then because we didn't have the stools fastened down to concrete. . . . We opened this side up and there wasn't no room to park, cars there and all the way down the road to Tarleton's store. . . . We called this the Colored Side then, now it's just anybody's side We opened the south side which we called the White Side at that time, and the Macon football team went to West Point to play football on Friday the 13th. They come back by the Pines with their dates, and as you know, we had a concrete dance patio poured out under the pine trees that had a neon moon in it. Believe it or not, we had a live orchestra out there complete with piano, and it looked like it was gonna rain, and I asked that fellow, "What we gonna do if it rains?" And he said, "We'll put a wagon sheet up, we'll cover up the piano player and dance on."

Taped conversation with Blume Triplett
December 31, 1985

By the time I walked into the Pines, Eppie had been dead a couple of years, and the place was a shell of its former self. Food was no longer served; Blume held court on the White Side with an occasional visitor stopping by to visit, drink a beer, and reminisce about old times. Rosie Stevenson, known as "Tut" by the clientele, operated the Black Side.

My visits were usually long: we would spend hours telling stories, sharing meals, listening to the jukebox and making pictures. There was a sense of family among Blume, Rosie and the rest of the neighborhood, all sharing a common history. And there was always something going on—a dog to bury, a birthday to celebrate, a chitlin supper for the regulars, funerals, reunions, children. Always something. I loved the place, and I loved the people passing through it, and in time I too became part of this small world.

In the mid-eighties Blume's health began to decline, and he moved over to the Black Side so Rosie could better take care of him. The White Side, clogged with debris he had collected over the years, became known as the "archives."

Though Blume's last few years were spent without sight, he enjoyed receiving a steady stream of visitors, smoking cheap cigars, listening to blues music, and making recordings of conversations and recollections, until a ruptured appendix put him in the hospital in 1989. He never returned to the Pines.

Central to the operation of the Pines and to the care of Blume in his later years was Rosie Jane Stevenson. Rosie as a young girl had helped Eppie with cleaning and ironing, and one night when a cook failed to show up for work her brother Bill volunteered her to cook hamburgers. From 1959 on she worked full time at the Pines. After Eppie died she would open up at noon, clean, wait on customers, and cook for and otherwise tend to Blume. At midnight she would lock up and go to her home half a mile away where she took care of her aging father, her two brothers, and her two sons.

A deeply religious woman, Rosie nevertheless enjoyed the high jinks of the place, whether it meant joining in the storytelling and merriment, posing for a picture with Blume waving a gun, or

helping him try to hatch peacock eggs in an incubator. In the final years it was her care and love that enabled Blume to remain at the Pines for as long as he did. The bond of affection between these two had grown out of more than thirty years of shared experience.

On the way home from Blume's funeral in July 1991, I stopped by the Pines. I had a key to the front door, and something drew me in. Whether it was the day, the heat, all the stuff, smells, or just being back after a long time away I don't know, but there was a palpable presence. The camera was in the car, and I wondered if it might be possible to convey this presence with photographs.

That was more than two years ago. Rosie, who will inherit the property, says she has no plans to reopen. Since Blume's death I have continued to make occasional visits—poking about, looking, photographing remnants of what was. The spirits seem to have departed, leaving only the collected detritus of a life. Even now when I go in and walk through those rooms I enter some sort of reverie. It's as though I'm the curator and sole patron of a forgotten museum viewing exhibits no one will ever see:

The Hong Kong pinball machine with the mouse skeleton and torn playing cards under its glass top

The safe Rosie and I had a locksmith open after the break-ins, which was filled with sacks of silver coins, two fifths of cheap whiskey, an unopened package of pajamas, and a drawer full of buttons

The hole in the ceiling someone came through the morning after Blume had sold the Wurlitzer for eighteen hundred dollars, taking his pants with the money in them from the foot of the bed while he slept

The Yellow Canary dining room with its moth-eaten deer head and its floor (knee-deep in crushed 78 records) done in by water and termites, where one night a possum appeared in the pear tree outside the window to watch me photograph

The ledger with each day's sales and expenses from January 1954 to December 1980. In the late sixties it became a daybook in which

Blume would record the weather and the day's events. Entry for April 26, 1969: "Willie Earl McCarthy shot hole in north window of colored side—about 9 o'clock with pearl handle 22 pistol (Saturday)" and for March 7, 1973: "A sad day for me. Eppie passed away this morning about 7:00 a.m. in Memphis. My world came to an end this morning (I loved her so much) We were married December 24, 1921." The last entry, December 31, 1980: "I shot my 12 gauge Remington shotgun 5 times and shot my 22 cal. H&R revolver 9 times at 12 p.m. bringing in the new year. I was all alone."

When the estate is finally settled, I suppose the place will be dismantled, and my visits will cease. But for now, I can still go and wander about, and from time to time sit in Blume's chair on the Black Side, look around the room, and close my eyes and try to imagine what the Pines might have been like back in its heyday in the fifties when Miss Eppie was running the show, and when Big Joe Williams the bluesman from nearby Crawford sang about it:

I get to thinkin' about my woman every evening before the sun go down
Yes, I get to thinking about my woman every evening before the sun go down.
Thinkin' about the good times we had in Mississippi, boys, runnin' 'round by Whispering Pines."

"Whispering Pines Blues"
Mississippi Big Joe Williams

Birney Imes
August 1993

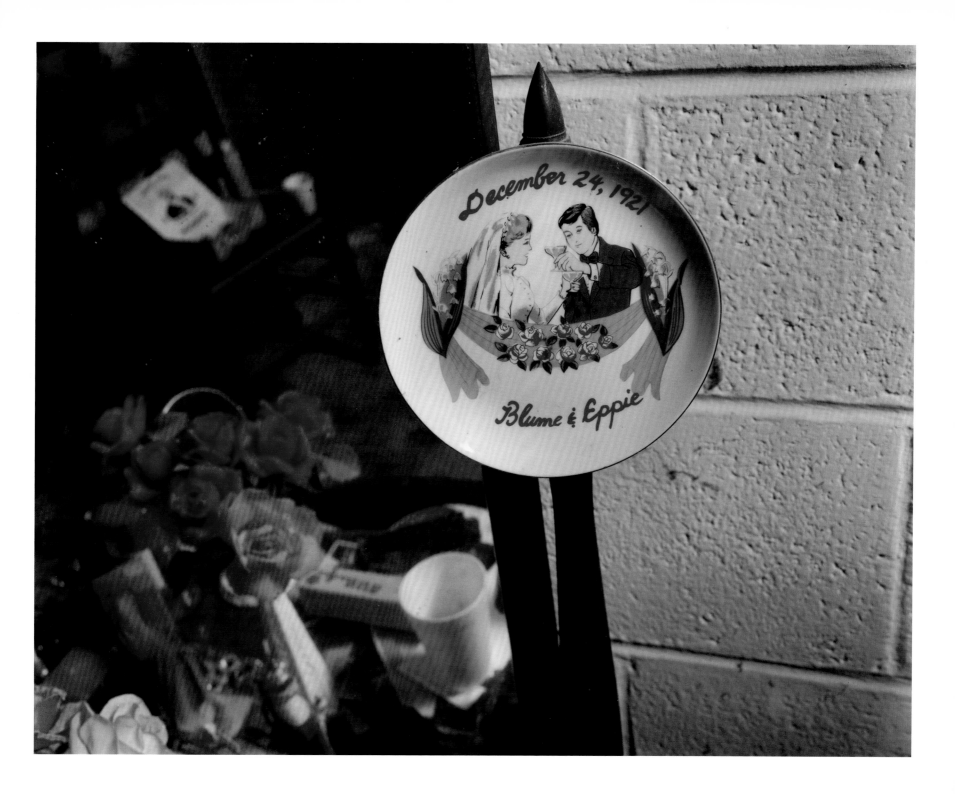

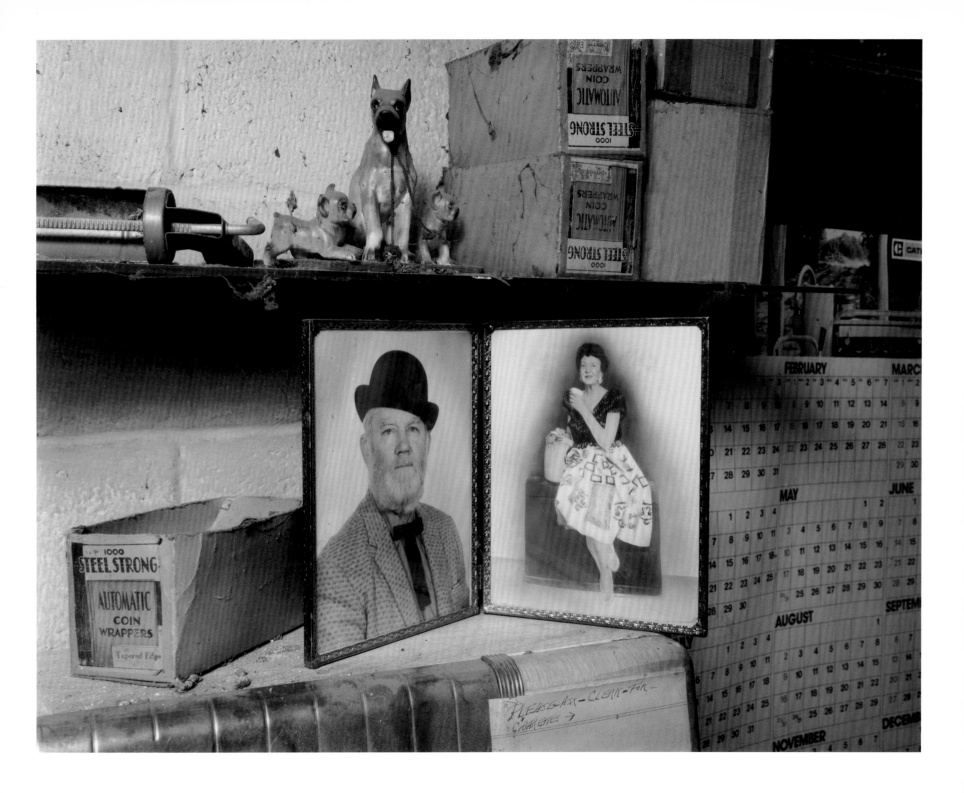

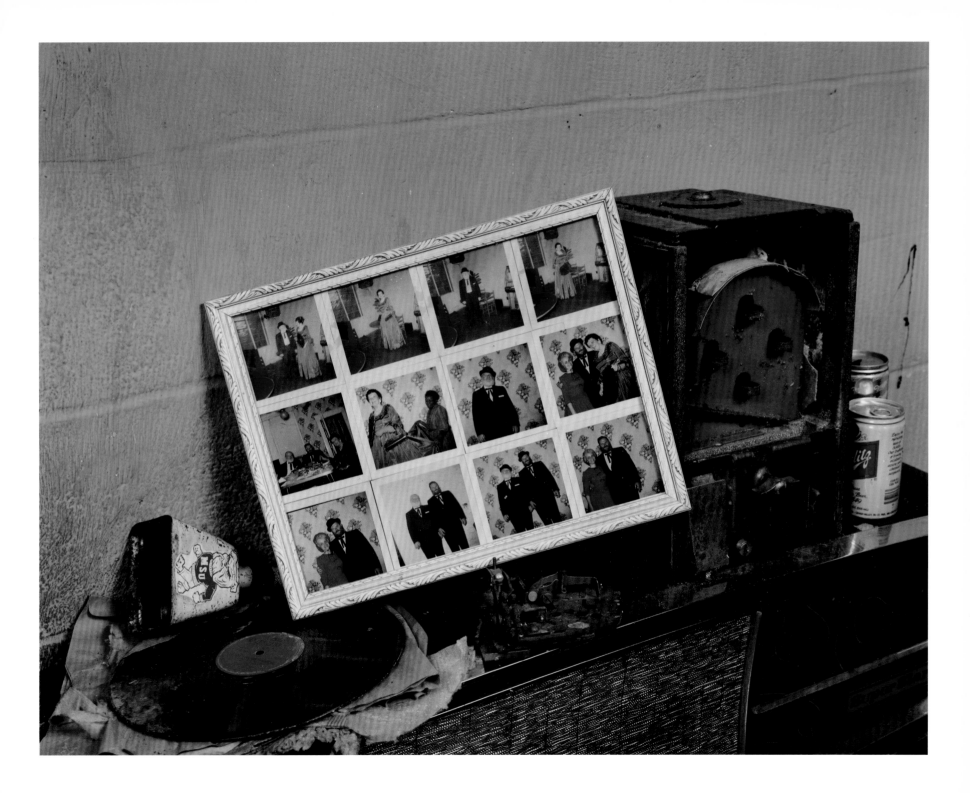

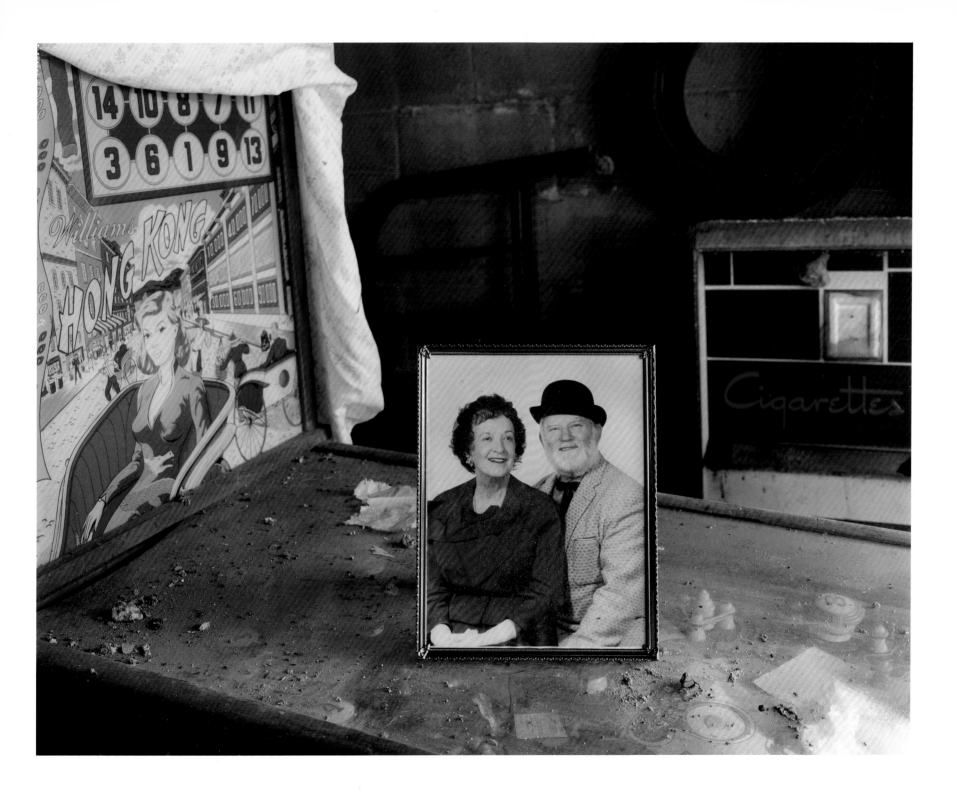

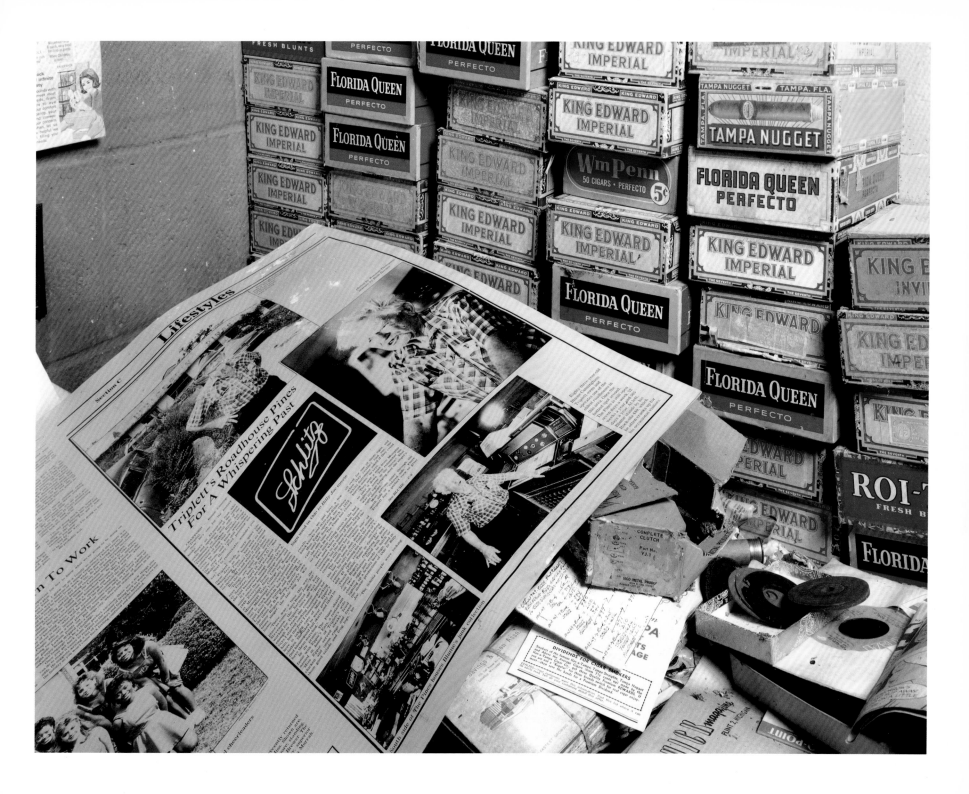

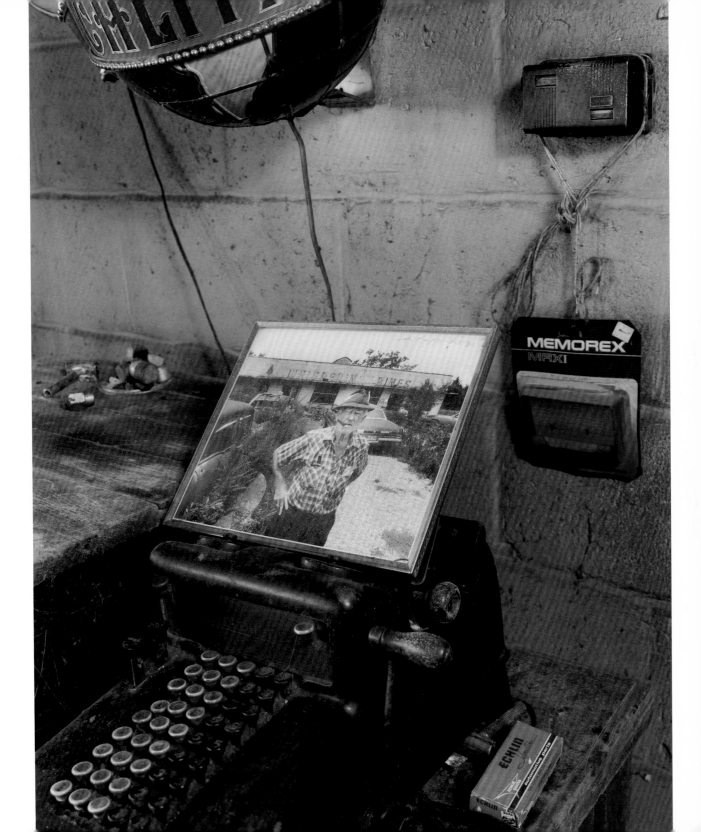

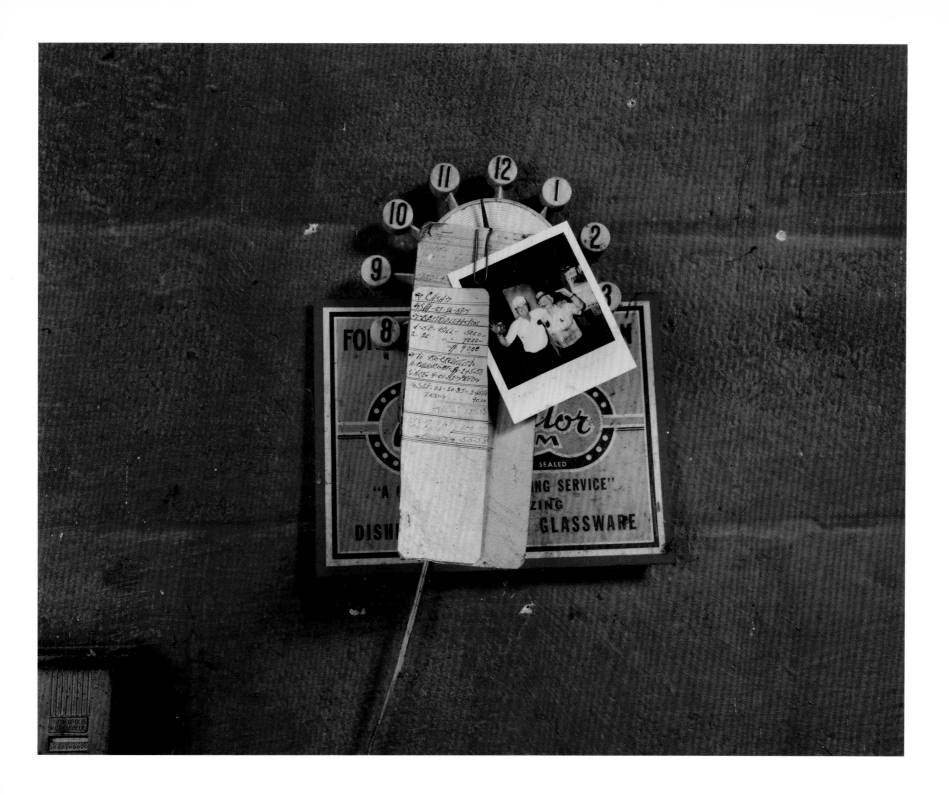

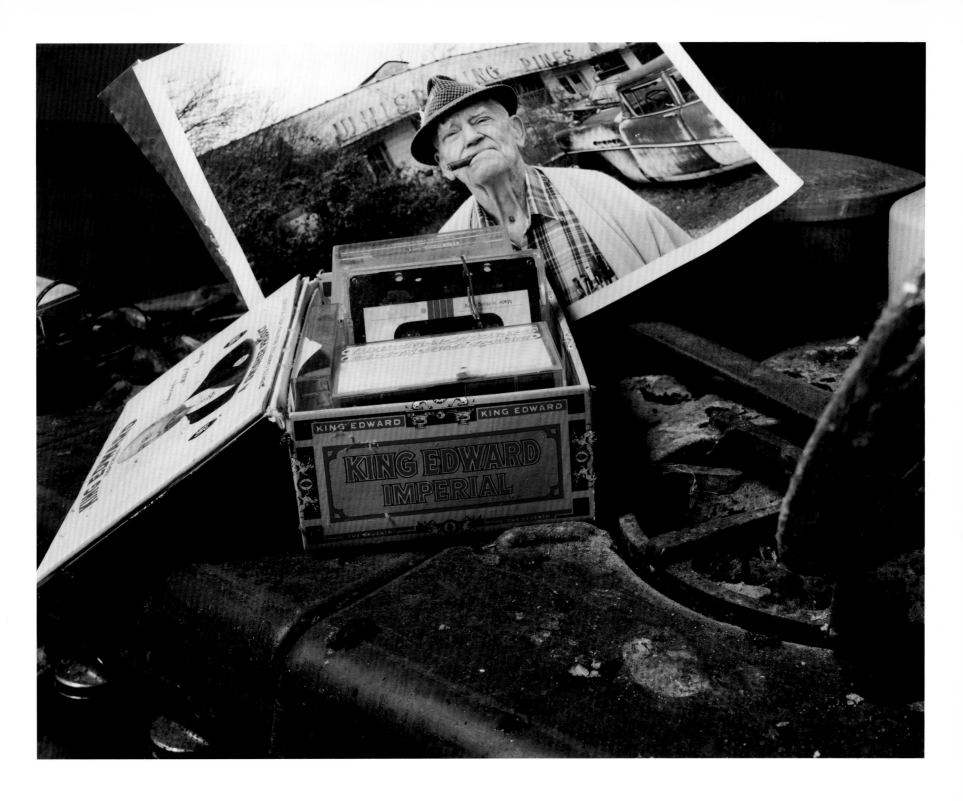

TITLES

ACKNOWLEDGMENTS

The production of this book would not have
been possible without the collaboration of many
people, and I am indebted to those who gave
freely of their ideas, energy, and expertise.

I would like to express my gratitude to Rosie
Stevenson and her family, T. P. Harkins, Clara
Triplett Doss, and to the patrons who over the
years allowed me to make photographs during
their visits to the Pines.

I am ever grateful to Trudy Wilner Stack for her
encouragement and steady support of this work,
for her many ideas that found their way into the
book, and for her wonderful introduction.

I am thankful to Jim Carnes who received many
phone calls from me at all hours during the book's
formative stages and who generously shared his
time, judgment, and knowledge. Thanks go also
to Larry Feeney and Anthony Accardi who
provided valuable assistance with sequencing
and technical advice.

To JoAnne Prichard and the staff at University
Press of Mississippi I give thanks. A special
appreciation goes to John Langston at University
Press for his careful design and for his abiding
commitment throughout.

The National Endowment for the Arts provided
assistance during this period for which I'm
grateful.

Thanks above all go to Beth who provided love,
support, and wisdom each step of the way, and
who with our children Peter, John, and Tanner
makes my life a rich and joyous one.

Library of Congress Cataloging-in-Publication Data
Imes, Birney, 1951-
Whispering Pines / by Birney Imes.
p. cm.
 ISBN O-87805-695-5. — ISBN 0-87805-696-3 (pbk.).
 — ISBN 0-87805-708-0 (ltd.)
 1. Country life—Mississippi—Pictorial works. 2.
 Mississippi—Social life and customs—Pictorial works. 3.
 Whispering Pines (Restaurant) I. Title.
 F342.I46 1994
 976.2'955—dc20 93-46800
 CIP
British Library Cataloging-in-Publication
data available